How To Draw

GRAFFITI-STYLE

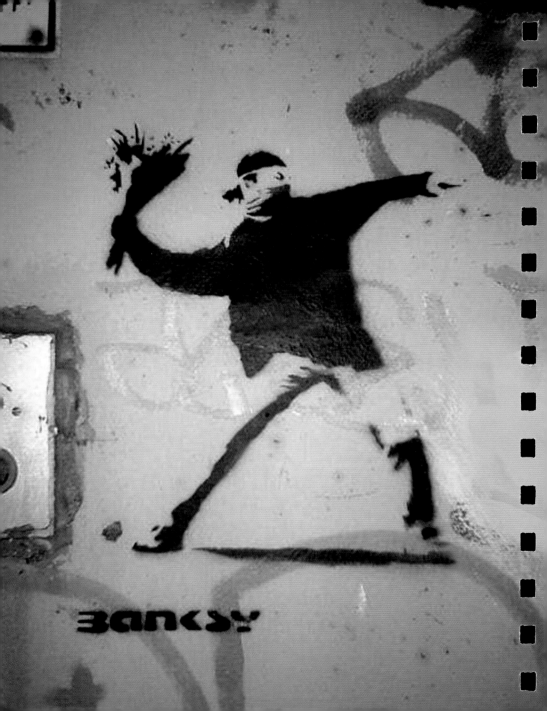

How To Draw

GRAFFiTi-STYLE

Kevin "Astek" Fitzpatrick

CHARTWELL
BOOKS, INC.

This edition published in 2011 by
Chartwell Books, Inc.
A division of Book Sales, Inc.
276 Fifth Avenue Suite 206
New York, New York 10001
USA

ISBN-10: 0-7858-2716-1
ISBN-13: 978-0-7858-2716-0
QTT.DGRS

A Quintet book
Copyright © Quintet Publishing Limited
All rights reserved.

This book was conceived, designed, and produced by
Quintet Publishing Limited
The Old Brewery
6 Blundell Street
London N7 9BH
United Kingdom

Project Editor: *Martha Burley*
Copy-editor: *Anya Hayes*
Designer: *Rehabdesign*
Art Director: *Michael Charles*
Art Editor: *Zoë White*
Managing Editor: *Donna Gregory*
Publisher: *James Tavendale*

Printed in China by Midas Printing International Ltd.

Contents

FOREWORD

Written by Frank Malt/Steam156
www.aerosolplanet.com www.londongraffititours.com

I have been involved in the worldwide graffiti scene for nearly 30 years. I have had the pleasure to meet the majority of top graffiti writers, and have traveled extensively to seek out graffiti. It is a major passion of mine, and one that I am happy to share with the world. The graffiti scene is one of many ups and downs but filled with mystery and excitement. It has come a long way since its early beginnings in New York City back in the 1970s. What began as an underground movement in subway tunnels and back streets has become a worldwide phenomenon. Now it's seen everywhere from music videos, clothing, and shop windows. Although often seen as vandalism, companies have recognized its potential selling value. Graffiti cannot be ignored, and there is a constant debating point on its artistic values. Every major advertising company has used graffiti art in some way and work is now displayed in galleries and museums around the world. It is not unusual for certain artists to sell paintings for thousands of dollars. The early pioneers of the art form have become heroes to the younger generation. They are not just seen as vandals anymore but professional artists that also make a living from the art. The early stages of graffiti began with a simple tag which included the writer's name and house number. It has since developed into such things as bubble letters and full-color pieces. The art form has developed into a serious business, and artists produce amazing work such as photo realism and huge murals, often adorning whole sides of a buildings.

When graffiti started there were no paint brands, specialist nozzles, magazines, or websites. Since the late 1990s there have been many paint brands launched, and cans are available in a wide range of colors and nozzles of all sizes to help artists to achieve different line widths. There are many magazines, clothing brands, and websites dedicated to graffiti art. Many graffiti events are held worldwide where writers battle to create the best piece. These events are well attended and have big prizes for the victor. As an art form, graffiti has come a long way since its humble beginnings, and the future looks very exciting.

Learning to paint graffiti is not an easy task. It takes lots of practice and dedication. Having an individual style is the most important thing when writing graffiti. Artists spend years trying to develop their own unique style, avoiding at all costs "biting" or copying another writer. This book will take you through the essential steps to becoming a graffiti writer. You are in good hands as your teacher is none other than one of London's most well-respected graffiti artists: Astek. With over 25 years of experience in the game, Astek has played a major part in the London graffiti scene and has done the lot—from major walls, to commissioned work, and gallery shows. He has also spent ten years involved in graffiti workshops and youth projects. This book will advise you on picking a name, taking you through the important practice of sketching, which as any writer will tell you, is of major importance when starting out. It also covers key elements such as lettering, characters, use of color, and the stenciling method, which has become more relevant than ever in the last decade. Want to learn how the pros do it? Then turn the page and get started...

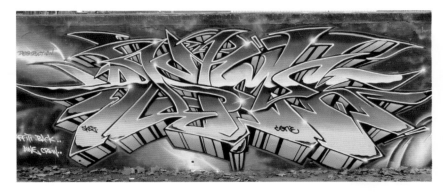

Above An Astek wild style piece, London 2010.

WHAT IS DRAWING GRAFFITI-STYLE?

This book will not only teach you about how graffiti art is made, but will also take you through how the whole culture of graffiti art evolved, and how it remains vibrant and changing today.

This book gives you a step-by-step guide to how to draw in graffiti style, and explores paint styles and techniques—plus what these techniques mean and why they have come to be.

The graffiti scene has many codes, rules, and classic styles, passed down through generations of graffiti artists. Discover how letters have evolved from the early tag through to the bubble letter, and what we see today. Explore the possibilities with 3D graffiti, using shadow and depth to bring your work off the page, wall, or even the canvas. All aspects of modern-day graffiti art (including the popular stencil art) are explained in depth.

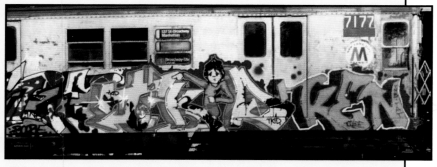

Above T-KID and Ken TNB's piece "The 1 Line" on a New York subway train in 1982.

Insider tips and tricks

You will learn the techniques of great graffiti artists and discover the various effects you can achieve with spray paint, such as thin lines for detail and fat lines for covering large areas. Using different caps (valves) on your tins gives you different effects and a defined style (see page 24–25). You will also learn the importance of your "black book," a hardcover sketchpad where you should document all your graffiti designs, with preparatory sketches for all your work and a living example of your style developing (see page 23). Within it you can produce graffiti effects in your desired style using a combination of pencil, pen, and paint pens before you take to the wall or canvas.

Where to create your designs

It's important to remember while reading this book that creating graffiti on areas that are private property and not sanctioned for spray-painted art is illegal. In order to avoid breaking the law, make sure that if you are spray-painting walls, you know that you have permission to do so. Creating your work in your black book or on canvas will always keep you within the boundaries of the law and you can let your creativity run wild, using the tips in this book.

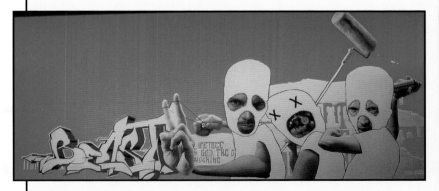

Above A modern piece of graffiti from the Maclaim Crew in Holland, 2007.

Styles of graffiti

There are large variations in graffiti styles. Graffiti is about being unique and standing out—having your own individual style helps you do just that.

The main styles are 2D (also known as "flat"), wild style, and 3D.

2D style

A classic graffiti style, 2D is instantly recognizable. The first pieces that ever appeared were 2D, and it is still heavily used today. A 2D piece would have an outline around the letters and a drop shadow to make it appear bold. Today it is common to add a 3D block to give depth and make the piece appear solid.

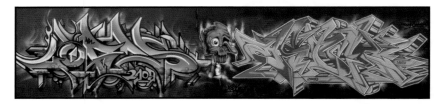

Above A 2D Loras and Astek production, London 2009. Astek's piece (above right) has an added 3D block which gives depth. Both pieces seem to glow from the background.

Wild style

Literally how it sounds, wild style makes your letters wild, disguising them to become unreadable, and interlocking them so that everything links up. To a novice, wild style could look like total chaos, but to a graffiti artist it can be read quite easily. Wild style will always have the solid 3D block and letters outlined. Color is very important in wild style, as a clever use of color can produce the most dramatic wild effects—sometimes color is even more intense than the outline.

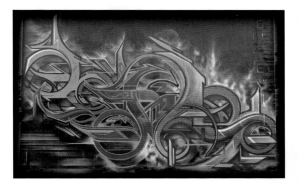

Left This wild style by Loras shows how abstract and artistic graffiti lettering can become.

3D style

The newest of the main styles, the basis of 3D design is that there is no outline. Instead, you bring the letters out using shades of color and shadowing effects. For a single-color 3D piece you would use around ten shades of the same color, carefully applying each shade to produce a gradient effect. The use of darker shades allows you to shadow some parts and to push other letters out.

Below This 3D-style piece by Astek (Brighton Graffiti Jam, 2006) is a great example of its kind—there is no outline, and the color gradient result is heightened by the flame effect which surrounds the piece.

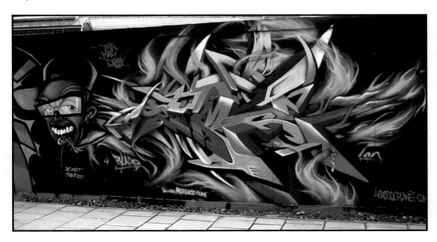

Roots of graffiti art

There are examples of people drawing or painting in public places dating back to the Roman times, but what we now know as graffiti art was started by kids in the 1970s from Bronx ghettos in New York. They painted walls and subway trains as a way of expressing themselves and publicly commenting on their lives and society.

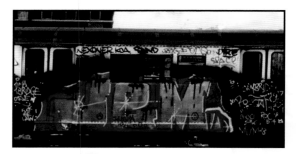

Left This piece, "Jem," which adorned a New York City metro, was produced by graffiti icon Choci. It was photographed in 1986.

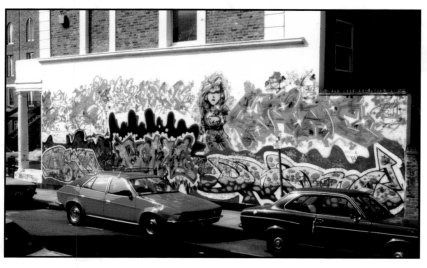

Above This piece in London by the artists Scam Brim (NYC), Mode2, Bando, and Drome was pictured in 1986.

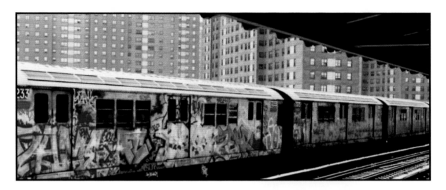

Graffiti is intertwined with hip hop culture, with break dancing (b-boying) and body-popping. The impact of rap music spread worldwide and developed into the new youth culture from the 1980s onwards. Pop videos began to spread the cool word and the bold statement of graffiti art to the masses. Through hip hop, graffiti quickly penetrated mainstream culture, influencing TV and advertising.

From the tag to the piece

The tag gradually developed into the piece as artists added extras to their tag (for instance arrows, halos, or a cloud). From this came the bubble letter; then sharp angles were added, giving the bubble an edge. From then on, everyone had their own take on graffiti, and new styles evolved.

Graffiti and the street

The street element of graffiti has a similar status to other street cultures like skating. All skate parks embrace graffiti, with art on the walls and ramps. Many skaters become graffiti artists and vice versa, as the street cultures meet and influence each other.

Why the tag?

Artists tag for notoriety—to get up and get noticed, to stand out from the crowd—when you have created your tag and established your identity you move on to producing dubs, throw ups, and then pieces.

Graffiti art today

Graffiti art is now recognized the world over as a legitimate art form. International graffiti events and festivals are organized by artists sharing knowledge and styles.

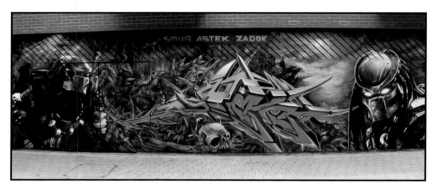

Above A graffiti collaboration between Smug, Astek, and Zadok, London 2010. In this piece photo realism is combined with 3D style and portraiture.

A worldwide graffiti movement has gradually developed, encouraging the art to become more accepted into the mainstream and taking influence from each country's diversity. Many graffiti artists travel the world to make links with other artists and collaborate on large-scale graffiti murals. These meetings are usually sponsored by big companies, who finance the artists' travel and provide materials, as a way of connecting with graffiti culture.

Graffiti and the mainstream

Today, graffiti is increasingly seen as a positive art form and no longer simply as vandalism. Some big cities have recognized the talent of graffiti artists by providing a means for them to create legal graffiti art, which has helped to develop the art form and lessened the amount of graffiti art that appears in the cities illegally. It's possible for young people to learn the art of graffiti with youth organizations that hire street artists as tutors. Graffiti is also a popular

form of mass communication as it can become street advertising. Many multinational corporations have employed graffiti artists to spray their logos and ad campaigns onto city streets.

Graffiti is increasingly used in graphics, or logos for TV, or on clothing. Clothing brands often base their labels on graffiti to give an authentic street edge, bringing in artists to provide real graffiti styles. By doing this, the graffiti artist's designs are popularized and worn by other artists. The music business has commonly utilized graffiti art since the 1980s, either in music videos, on album covers, or other merchandise.

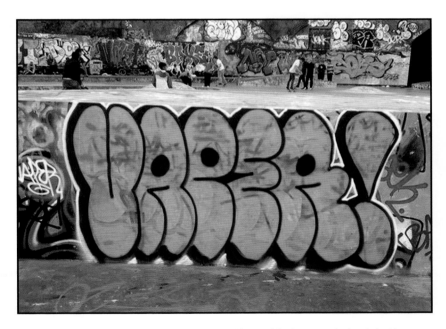

Above This throw up design is by the graffiti artist Vaper.

Graffiti as high-class art

Art galleries have invited graffiti artists to create exhibitions and sell works as high-class art, and this has proved very successful all over the world. Art galleries may also choose to decorate their interiors with graffiti designs to show they are in touch with cutting-edge developments in the art world.

Above A canvas by the graffiti artist Seak, 2010. This piece shows a high level of technique in blending, using complementary colors successfully.

Still a relatively new art form, graffiti is highly sought after and some artists are very well known all over the world. Their work is collected like any other famous artist's, and can sell for thousands. The prolific artist is even more sought after, and anonymity is very appealing to the buyer or collector. Prints of these artists' works sell for very high prices, elevating the artists to become superstars of graffiti art. This helps create space for new and up-and-coming artists to move into the scene.

Graffiti and business

Prominent businesses have bought into graffiti art to make them appear to have a street edge, or to be in touch with what is cool. Often they choose to have graffiti canvas work hanging on their walls or to commission an artist to come in and produce a unique one-off piece.

Graffiti workshops are also increasingly used as team-building exercises within some major corporations, where a graffiti expert is hired to conduct a group project to create a graffiti installation. Employees get the chance to develop their team skills, working together to produce a collaborative piece of artwork such as a mural on a wall, as well as enjoying the freedom of creative expression.

Graffiti art and politics

The Prime Minister of Britain, David Cameron, catapulted the graffiti artist Ben Eine into the limelight when he presented Barack Obama with the painting "Twenty First Century City." This firmly established graffiti art's place in the international highbrow art world.

Graffiti art and the future

Graffiti is the fastest moving form of art, changing constantly and adapting to its surroundings and cultural influences. Stencil art and sculpture have contributed to this process by showing how diverse graffiti can be. You can now hire professional graffiti artists to create designs for all sorts of projects, such as in the home and in offices, school murals, stage backdrops, clothing and jewelry, business branding, logos, vinyl sleeves... even working with architects to produce 3D sculpture and buildings. The possibilities are endless, and illustrate how widely accepted graffiti as an art form has become in modern society.

WWW.ASTEKZ.COM

Left Graffiti-style artwork is increasingly used for typography and website design.

The popularization of graffiti

Technological developments in recent years have further globalized modern graffiti culture. A quick glance through a graffiti magazine will show you artwork from all around the world. The Internet has revolutionized the ways in which ideas and techniques are shared in the graffiti community and critiqued by other artists, through online galleries and forums. It is also an easily accessible inspiration for those who may have never thought to design graffiti on their own.

Forums and online galleries

In the mid-1990s, graffiti first appeared on the Internet and was to change graffiti forever. Graffiti artists could display their work in an instant and communicate with other artists all over the world. Online data websites like artcrimes.com quickly linked up the world of graffiti in one place. Their vast online galleries contain work from every corner of the world by all levels of artists. Along with this came the graffiti forum where global artists could share ideas and discuss graffiti art in general. The forum is reminiscent of the "writers bench" in the Bronx area of New York or Covent Garden, London during the 1980s, where artists would meet and discuss the scene and how it was developing. This is now discussed using the Internet on many different sites, not even just those with graffiti as the main topic. Many social networking sites and photo log sites seem like they were made for graffiti, highlighting how graffiti moves with the times and adapts to the current trends on the internet. Graffiti artists use any method they can to show their work, making the Internet a vital part of the scene.

Above The digital world has made image swapping and technique discussion easier.

Photoshop

Most graffiti artists are computer literate, and use these skills to create their art in computer graphics programs. Photoshop is widely used all over the world to create graffiti, opening up a whole new approach for the graffiti artist. In recent years, graffiti imagery has become standard in many different art forms, especially fashion where designs can be silk screened onto clothing (see page 216). A talented artist can try to create their art in as many forms as possible using digital methods.

Chapter 1
Tools

Graffiti is an art form with many different styles and techniques. Before you can begin to learn these and start to develop your own drawing and painting style, there are a few essential materials you need to hand.

TOOLS

Before you produce your graffiti styles you will need the right tools on hand to begin.

Sketching materials

There will be a lot of sketching and drawing to be done. Paper, a pencil, an eraser, and a sharpener are a good start. Tracing paper is recommended to perfect the parts of your work you like and want to keep. Any pencils are okay—try not to use something too dark, as it will make it hard to rub out. A good tip is to use a 4H pencil and always sketch lightly.

Soft pencils are good for the provisional sketching stage.

Colored pencils can help plan color blend combinations.

A hard pencil, such as an HB or 2H, can be useful for precise outlines.

The black book

A black book is a graffiti artist's sketchbook, log, and journal of what he or she has achieved and a record of how their work is developing. The hardcover is usually black, which gave the book its name. Keep all your sketches in your black book. Your ideas should be reworked in smaller sketchbooks before adding to your black book, as your black book should contain your best work only. Carry your black book around at all times, as you can show it to other artists to get their opinion of your style and where you can improve.

Above Your black book is like a blank canvas. Graffiti artists personalize their books with stickers and other design inspiration.

TIP:

Ask other graffiti artists to add a piece to your book—if you're a new artist starting out, other artists will happily add a design. The artist could put your name in the book in their style as a slice of influence from them.

Spray paint

Your ultimate tool is spray paint. Spray paint is fast and quick-drying, and applies to any graffiti surface. Spray paint isn't used in your black book, but you can test color combinations on any other surface. With spray paint you can achieve many different effects and you can interchange the cap to achieve thin lines for detail, or to create fat lines to cover an area quickly. Learning how changing caps enables different spray paint techniques is an important skill, and many new graffiti artists struggle with this at first.

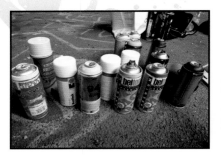

A typical graffiti artist's selection of spray paints.

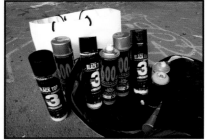

Black paints and chrome paints are used for strong, bold outlines.

The science of caps

Caps come in skinny, medium, or fat. There are also soft options that work with reduced pressure and slow down the spray of paint. All the latest spray paint brands are produced for art and come with the cap system. Buy your caps separately, even though some brands come with a soft cap already on the can. This system has been developing for around ten years. Before this, artists had to find and tailor-make their caps using caps from air fresheners and other household aerosols. This was a difficult task, but allowed them to develop varied skills according to whatever cap they had to contend with. Today it's simple, so you can spend time to hone your can-control skills: perfecting what you can do with a spray can. Spraying an accurate line is crucial for your outline. Following these lines to add a highlight or a border requires the same level of accuracy. When you have perfected your can-control skills you will be as fluent with a spray can as you would be with a pen.

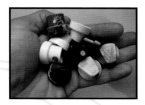

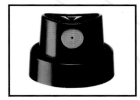

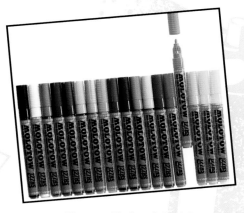

Above and below right Molotow markers come in a fine array of colors and widths. They are recommended by graffiti artists for their blend potential.

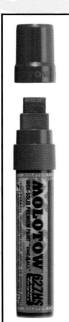

Paint pens

Fine-liner pens, quality color markers, and paint pens are used to produce your advanced sketches in your book. When you have your styles ready to color and fine line, these are the tools for the next step. Tracing paper can be used to apply your image correctly to the page then a fine liner is used to go over the lines. After this, erase all trace of pencil, leaving a perfect black and white sketch. You can leave your sketch as it is or add color. Colored pens like Letraset markers or paint pens can help you achieve the look you want for the finished piece in your book.

Above A selection of specialized caps available for graffiti artists today. Skinny caps can achieve the thinnest of lines for detailed work, whereas when you want to cover large spaces quickly, a fat cap is preferable.

Chapter 2

Choosing an alias and the art of the tag

One of the most important parts of your graffiti style will be the tag that you create to establish your identity within the scene. In this chapter you will learn why graffiti artists tag, and discover techniques for creating an eye-catching tag.

YOUR ALIAS

Choosing your tag, or alias, is very important. A tag is your stamp or your mark for other graffiti artists to know you by. Firstly, your name must be original and not sound like anyone else's. You don't want to be mistaken for another artist or look like you're biting (copying) someone else, as this is frowned upon in the graffiti scene. You have to bring something fresh and new. Remember when choosing your tag that graffiti is fueled on originality.

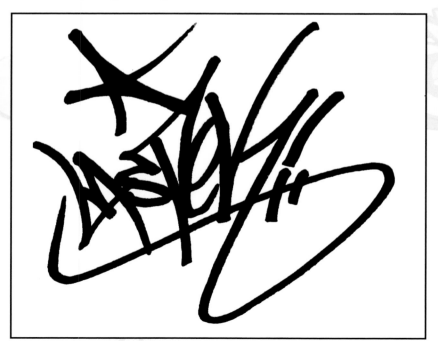

Above Aerosol Planet tag logo by Astek.
Below left Astek's tag.

Inspiration for your tag

You can take inspiration from anything you're interested in. Many artists are inspired by comic books and fantasy art. The super hero is a big inspiration. As your tag is exclusively yours, when you're creating graffiti, it's something you become known by. People will wonder who you are, like a masked hero—especially if your tag is easy to read and everywhere.

The concept of the future is an inspiration to all artists when planning, sketching, and coming up with concepts, as graffiti is a relatively new art form and constantly evolving, with artists always striving for new ideas that haven't been seen before. Artists have been accused of abusing the environment by creating mindless vandalism, when in reality it is about enhancing the environment, and creating positive community feeling. Graffiti is not an art form that is created for the sake of rebellious destruction. In fact, it is an innovative and truly original art form that is meant to bring esthetic pleasure to its audience, like any other recognized art form.

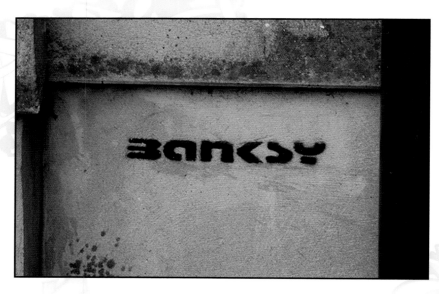

Above Banksy uses a stencil for his famous tag. Stencils are great for speed and precision.

Your tag may be obvious to you immediately. To choose your tag, you could use a nickname from your past—you may have been given a name by a group of friends or your family. If not, you need to make up something that sounds good, and looks good written. Choose a name that is not too long. Five letters or fewer is best—no more than six. Your tag is your graffiti pseudonym or your alias, and is mainly for the benefit of other graffiti artists. Outsiders do not need to know your tag if they're not involved in graffiti—your tag is an alias for your graffiti career only.

Numbering your tags

When tagging first appeared, artists wrote their street number beside their tag, for instance T-KID 170 or Taki 183. This showed others artists where they were from and how "all city" they had gone. To go "all city" is to get your name up across the entire city area, so everyone knows who you are and has seen your tag.

Numbers are still used now, but not as often, and not for the street you come from. More often they are used to just look and sound good, or add a unique touch. Something personal and associated with you is best. You can even use a symbol or a character. Your tag is your mark—a stamp to identify work as yours and make a name for yourself. Starting out you can change your tag until you're really happy with it. This is okay as it gives you experience, but you will need to eventually find that perfect name. Your name will stay with you always, so it's vital that it's original. The more unusual your name is, the better. Words that are made up are great—graffiti is a worldwide culture, so if you choose a popular word you will find many artists out there already using it. Numbers can also be added to make your tag different but if there is still someone with that name, you'll never be truly unique. You can try sketching out letters to get a feel of what letters you like and are good at, and build your tag this way. Don't worry if your style is basic at first—you can develop it as you gain experience.

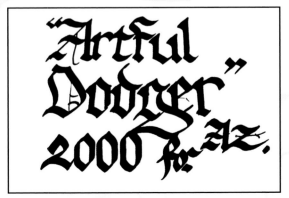

Left The calligraphic style of Artful Dodger's tag has a distinctive approach.

Knowing your tag

You should come up with something good that you can write well. If you are struggling with a certain letter then don't use it in your tag, as tagging is about repetition. You must be able to write it fluently—once you have your tag down, your style will follow and develop from there. Learn and perfect your tag until you can write it with your eyes shut.

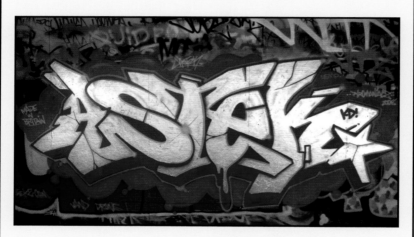

Above Be distinctive—it will be an advantage to you through your graffiti career and pick you out of the crowd.

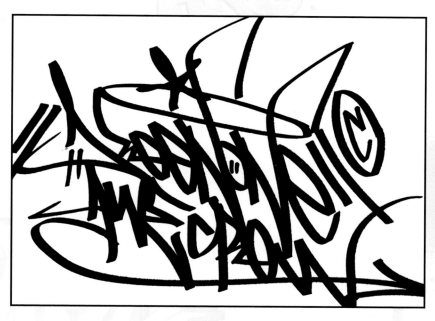

Above This is Keen's tag. It's letters and embellishments are almost abstract in form.

Tag style

In recent years some artists have developed a quick one-line throw-up style (see page 86), and use only that instead of a tag. Some use a character, a face, or even a symbol. This is a simple but very effective approach, and is increasingly popular. Famous graffiti artist Stay High 149 used both a character and a tag in the early days of New York graffiti. You can get lost in a sea of tags, whereas faces and symbols stand out and are a refreshing take on tagging. Another recent trend is stenciling, which works in the same way. Some stencil art will have a tag with it, but some is so unique that it speaks for itself (a Banksy stencil or a Blek le Rat stencil is instantly recognizable both by the public and graffiti artists). Unlike graffiti artists, street artists like Banksy want to broaden their audience so the public can understand their work, as well as other graffiti artists. It's this idea that has given rise to the stencil street art movement.

How to tag

Graffiti tags are usually sprayed or written with a marker pen. A chisel-tipped marker is usually used to add style and flow like calligraphy. Most artists would agree that calligraphy is a close relation of tagging style, and respect all forms of stylistic writing. Pioneering London-based graffiti artist The Artful Dodger used a calligraphic style of tagging. Chisel tips are universally used by all graffiti artists, and the larger in width they are the better.

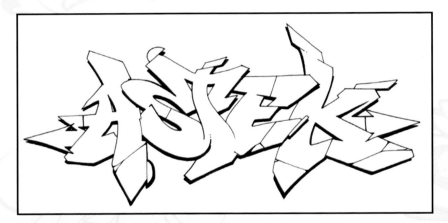

Above Simplified into lines, a tag becomes more comprehensible to follow.

Your tag should be able to read at a glance and put up (written) just as quickly. Pens have been favored for tagging over spray paint for many reasons, but mainly because pens are easy to use and look good on most surfaces. For larger tags, for walls and train tracks, spray paint would be used with a fat cap (wide-angled nozzle) to achieve maximum effect. Artists can even modify spraying devices like fire extinguishers to spray huge tags high up the wall, similarly you could use a paint roller and an extended roller pole for neat and tidy effects. These roller techniques are heavily used in the US. New artists may use pens for a long time before they move into spraying, as pens are part of the evolution of tagging, and where most artists start.

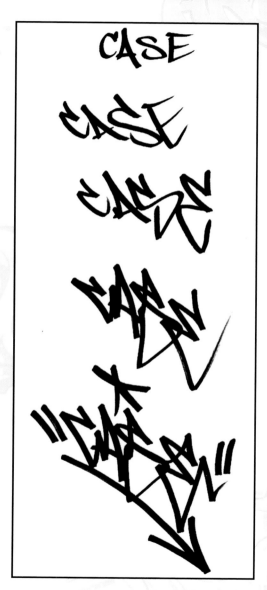

Left Starting with simple letters, your tag can become as styled and as embellished as you desire.

Style it

Added effects are used to stylize or jazz up your tag, like an underline with an arrow, apostrophes either side, and a halo or a crown on top. A crown on top has added symbolism and means you're a graffiti king or queen—someone seen to be "all city," or very skilled. Across the world tagging styles are very diverse especially in South America. Some countries have formed their own tagging identity.

Below This rounded slice is a popular effect and could be used for adding a quirky style to your lettering.

Below Cuts running through letters add a geometric design and separate elements.

Do you want it to be read?

When it comes to tagging style you can stylize your tag so it's unreadable to those outside the graffiti scene. A wild tag is for the public to see, but only for other artists to read. You can learn to create both readable and unreadable

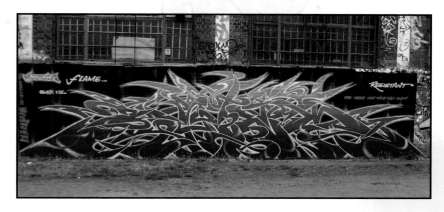

Above Tags can become more than just a name. In this wild style piece, Astek has produced a work of art. London, 2002.

tags. Artists think carefully about where they place their tag. Most places to write tags are illegal—artists seek out spots to paint that are quiet and possibly derelict, but still private property. In order to avoid breaking the law it's better to seek out areas set aside for graffiti artists' work: such as abandoned buildings, or community walls in parks—walls and halls of fame where graffiti is legal.

You will see tagging everywhere in the streets, and much of this is illegal. When artists get their tag up high somewhere prominent this is called a "reach," to tag walls or the street is called "bombing" or "street bombing." This use of the word bombing derives from the Vietnam War, where returning soldiers wore their nametags around their neck. Street tags are usually buffed (cleaned off) quite quickly. To combat this, artists use staining ink so when it is buffed a stain remains. Some artists go to extreme lengths to create deeper and stronger inks for their markers by mixing and adding different inks. Graffiti artist KR has developed his own brand of ink called Krink and it is marketed all over the world, raising KR's profile and highlighting the fact that artists can tailor-make their own tools as their style develops.

Developing your tag

Step 1: To create the calligraphy effect, hold your marker so the broad side is flat to the page. Write out your tag, trying to keep each letter the same size and giving good balance to each letter.

Step 2: Now, keeping the marker at the same angle, put a slant on your letters, leaning them to the left. Remember to keep your tag balanced. Pressing down quite firmly on your marker will help with this, and will help the ink to flow consistently.

Step 3: Now it is time to add flow to your letters and give them style. Lots of letters hold the same shapes and attributes (for instance, note the similar letters P and R). Try adding similar styles to the letters that look alike and keep the same flow through your tag.

Step 4: To add more style to your tag you could add ticks or extra lines to the ends and beginnings of your letters. Try to gradually advance your letters one at a time, to get the feel of writing new styles.

Step 5: Learn to write the preferred version of your tag. You can practice by repeating your tag over and over again. You should never get bored of writing your tag. Most artists write on anything they can, and when they can, from their black book to doodling on a newspaper.

TIP:

Tagging in spray paint will come naturally when you have mastered a skilled tag style. By all means you can try it out in the early stages, but pens are the best place to start. You can use pens anywhere, and you can keep them with you at all times for chances to practice. Spray paint is for outdoors only, and for when you are ready and confident to use it. You will find that marker pens and all other types of pens will stay with you all through your graffiti career.

Step 6: Most tags will be spray-painted or written very quickly, but there is always a time for a fully stylized tag. You can add flowing underlines and slick arrows. These add size and style to your tag. Try adding some elongated apostrophes. Stars, sometimes circled, are very effective and widely used either above, below, or at the end of your tag. Other popular extras are a halo or a crown above your tag to show your graffiti credentials.

Chapter 3

Basic techniques

Now that you've got the materials, and have created your graffiti name, you are ready to learn about the various techniques you need to develop your graffiti style. This chapter will take you through all the techniques every accomplished artist uses in their creations.

BASIC TECHNIQUES AND TERMINOLOGY

Graffiti is full of techniques and effects, and there is a wide range of terminology used, which will be explained in this section. Everybody is different and uses slightly different phrasing to illustrate what they mean, although there is a universal language of graffiti.

Left This close-up of graffiti lettering shows a crack, which is a popular design feature.

Classic techniques added to a letter are the same on paper as on the wall. Techniques like cracks, shines, and highlights are the most favored. By adding these techniques you can give your letters realism. Cracks in letters always give a solid rock feel, and with highlights will also bring out the letters from the wall. The same crack-effect in white gives you an electricity effect—this can be an amazing technique.

Tag terminology

This at-a-glance reference will help you in your quest for graffiti domination.

rounded slice　　　　cuts　　　　slices

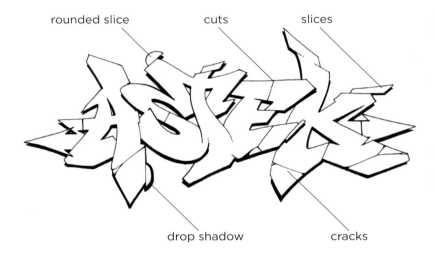

drop shadow　　　　cracks

Fading

Fading is the same as blending. An easy and simple fade is blending two colors together with spray paint (a two-tone fade). By using the same shades of color or two colors that are similar, like pink and red or orange and yellow, you fill your letters in halfway through the middle. Use one color at the top and one at the bottom and then fade from the top into the bottom, angling the spray can down to make it blend.

Fading is used for a lot of effects and can be done in many ways. You can also cascade colors together by blending many colors that work together well. Some color choices do not work—blue will not fade into red. You will learn that sometimes it is best to fade the lighter color into the darker one. Fading any color into black has created an effect, which is heavily used for character and detailed painting.

How to fade

Step 1: Dark colors at the bottom work well with a light color at the top, but you can experiment with this. See the chapter on color (page 182) for tips. Using a soft cap like a banana cap, fill in the bottom half of your piece in your choice of color.

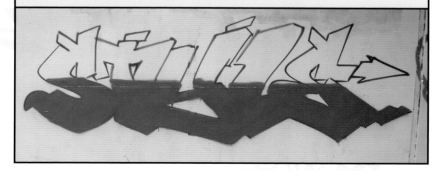

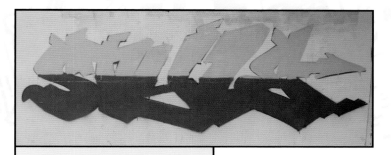

Step 2: When the first color is complete, add the second color to the top half in a straight line. Check all parts of top and bottom are filled in.

TIP:

When using shades of the same color, it is easy to create the fade naturally.

Step 3: Using the top color with the can angled downward about 6–8 inches away from the wall, point in the direction of the darkest color, and spray side-to-side, keeping the spray as even as you can.

TIP:

The spray paint naturally fades together when you spray from the top angle of the wall.

Step 4: To help the fade to blend more, pull the can back by about 15 inches, straighten up, then lightly spray again, keeping your fade even.

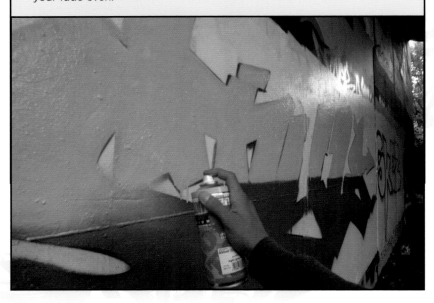

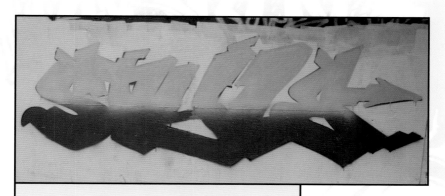

Step 5: When fading sections that join, you should treat them as one thing and fade them all together, this way your fade will be even. Continue your fade across your piece, step back and check you have sprayed evenly.

TIP:

Soft caps are good for fading most pieces. If fading a large area a fat cap is recommended.

Border

You border or second-outline your letters with a single key line around them, to bring them off the wall. This is an important part of a 2D or wild-style piece. With a 3D piece it's not really used, as shadowing brings out the letters, but it could still be added as an extra effect. Your border can be one single line, or a thickly exaggerated line. Using other colors can create a glowing effect around your letters. Other colored borders include shines and drip effects. The border is designed to lift your piece off of its background—your piece is meant to stand out, not the background. Learning to use color in a clever way helps you achieve this effect. In a joint venture with other artists you could all use the same border colors to show a link to each other on the wall.

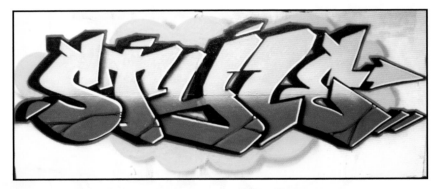

Above Your border helps to bring out the letters from the background.

How to create a outline

Step 1: Outline your piece using a skinny cap, a soft cap, or any cap that gives you a thin, even line. Start outlining long straight parts first, moving on to large curved parts. Be confident when outlining and don't break the flow—try to create the outline in one go.

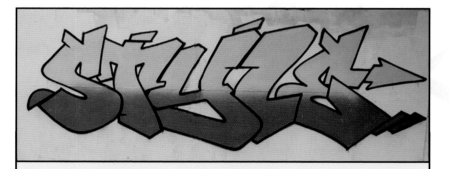

Step 2: Don't outline too fast—a lot of new artists think speed is important here but this is not true—slow and even is better. When your outline is even all over it will look stylish, even if it is a little thick. It's the perfect balance of the outline that makes a piece work.

Step 3: When your outline is complete, add your 3D block. 3D can go in any direction. Apply your 3D to all sections where 3D would be, step back, and check for any parts you may have missed.

Step 4: Now your 3D is accurate, fill in your 3D block. It is best to start with one color of 3D until you understand 3D properly. Then lines and effects can be added to enhance your 3D block.

How to create a border

Step 1: Border your piece with any choice of color—a color you have not yet used is always good. With as much accuracy as possible, add your border to the inside and outside of your piece.

TIP:

Although it is a good idea to try a new color for your background, it is vital that the chosen color complements others in the piece. See page 186 for information about complementary colors.

Step 2: Small sections inside your letters are difficult to border. It is very easy to make mistakes, but this is easy to fix later on.

Step 3: Fix the insides of your border by re-outlining the affected areas. Keep this in mind when bordering.

Step 4: Effects can be added to your border, like dots and ooze dripping onto your letters.

Step 5: More effects such as drips can also be added. Effects can even be added to the effects.

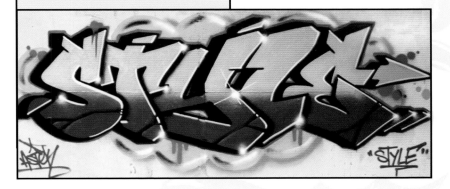

Background

A common background is a floating cloud behind letters, in a different color to your piece and border. This effect can also be a huge splat behind your letters by simply adding a splattered paint effect. You can add depth and shadow to these effects by adding darker or lighter shades of the same color for a more intense 3D look.

Below In this close-up image you can clearly see the layers that are built up and the cloudlike effect of the bubble background.

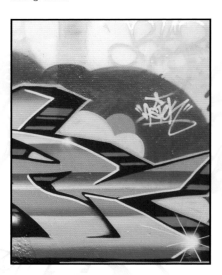

Highlights

Highlights are treated in the same way as a border, but are located inside your letters. White is the obvious choice for highlights. One side of all of your letters should have highlights, and a simple shine effect to the edges or angles makes your piece shine.

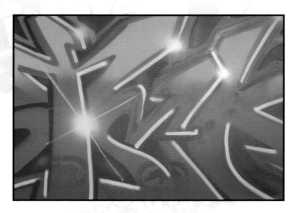

Above Highlights add a glamorous twist to a piece.

How to highlight

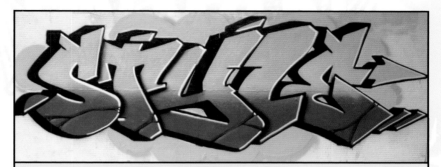

Step 1: Highlights are a vital part of a piece and bring out each letter. Highlights are parallel with your outline, one side of all of your letters. It requires some skill to highlight accurately. A skinny cap is always used for this.

Step 2: To improve your accuracy, try to practice lines before pressing down on the cap. Move the can up and down where you are going to spray (as if you are miming the action) and when ready press down and spray your highlight.

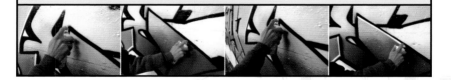

Step 3: Shine effects are added to some angles of your highlights. Pull your can back by about 10 inches and spray. Pull back more for larger shine.

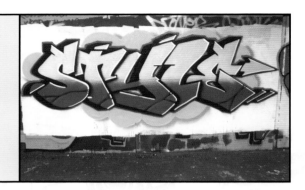

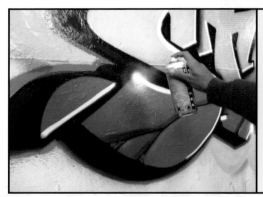

Step 4: Shines also look good at the start or at the end of your highlight. Shines can go on anywhere and are great for hiding small mistakes, so if you have drips where two angles meet, put your shine there.

Step 5: To create a shining highlight, the can must be almost touching the wall and always used in a forward direction. This must be done evenly and fast to achieve the thinnest line.

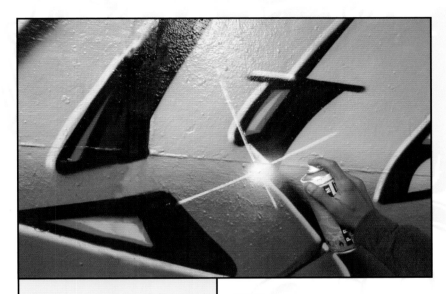

Step 6: Then, in the opposite direction, create an X and apply the same line, trying to keep the same sort of width and length to the first line. Finally, add your shine to the center.

TIP:

Highlights are difficult—practice and confidence are needed, as it's easy to mess up your outline when you are applying them. Stay confident, as you can re-outline and try again if need be. If you make small mistakes you can hide with a shine, which might even improve the overall effect of your piece.

Finishing effects

An effect like a star or a cross can also be added as a last finishing touch. This is done very quickly with a skinny cap for best results. 3D highlights work in a similar way but are added to your letters by fading white into the edge of the letter rather than introducing sharp lines.

Shadowing

Shadows in graffiti art work very well. You could simply add a black fade or another dark color to the edge of a letter, pushing each letter out from the one beside it. Another approach is to add a shadow underneath your piece or background cloud. Shadows are done in dark colors only. More advanced shadowing is done with different shades of the same color. Shadowing a 2D piece or a wild style is optional, but with a 3D piece it is essential, as 3D painting relies on shadowing to separate each letter from the other. The effect works well with all styles.

How to shadow

Step 1: The most basic shadow can give a great effect. Using your outline color or a more transparent color, gently add a shadow to the second letter. Don't let any spray get onto the first letter.

Step 2: Every part of your letter that is touched by your previous letter will have a shadow.

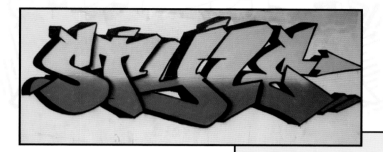

Step 3: Continue this across your piece.

Step 4: You also add a shadow to your background cloud. This can be black or a transparent color, or you could match a color to the background color. A middle blue over light blue works well. Shadow your cloud to one side only.

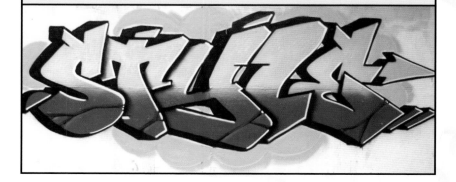

Step 5: Applying shadows can cause overspray, so repaint or touch up the edge of your cloud to keep it clean and separate from your shadow.

Step 6: Touch up any parts of your outline affected by overspray.

TIP:

To enhance this, the same effect in white should be added to the other side of each part of your cloud. This white fade is a highlight and the finishing touch to the bubble effect.

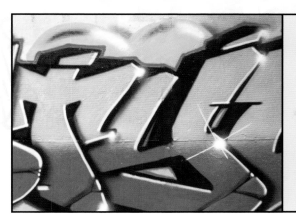

Step 7: The inside of your cloud can be shadowed to give a 3D bubble effect. Add a shadow fade effect to one side of each rounded part of your cloud with a dark shade.

Detail effects

There are many techniques to make your letters slick—even appearing cut up or sliced. These are mostly used at the end of a letter and at the end of a piece (for instance extended full stops) but can go anywhere you feel they fit.

Slices are usually rectangular but can be any shape—they can be rounded or warped to fit any kind of style. Letters can be cut in half, adding more detail—using all of these techniques together adds a complexity to even a simple style.

Arrows

Arrows are universally used, and have been since graffiti began. You could use many different arrows in your style. Arrows say, "look at me," and symbolize that you burn (mean business) or your piece burns. Arrows can be at the ends of your piece, giving symmetry, or all over like in a wild style. They can stab through another letter or cut a letter in half. Even in tagging, arrows appear mostly as underlines or pointing straight at your tag, to draw attention to it. Arrows are generally used by graffiti burners, after much experience in the graffiti world, but this doesn't mean as a beginner you can't use them in your art. You can—arrows are a major part of graffiti-style drawing and should be used.

Chapter 4

Preliminary work

All the graffiti work you create should be well prepared. Careful planning will enable you to get the most out of your designs and develop your technique through each stage of the process.

PRELIMINARY WORK

Like in any creative art, graffiti takes preparation and planning. Even a sketch should be planned and perhaps traced into your black book.

Working in your black book

Your black book is for your final, best creations. You may have other sketchbooks for practice and rough sketches, but your main one is to show other artists your finished pieces and ask experienced artists to contribute.

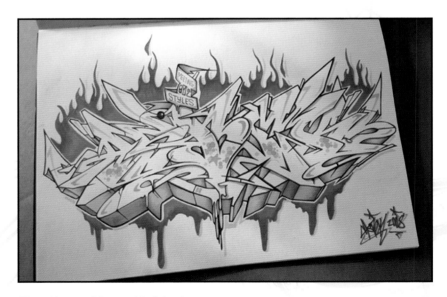

Above Your work in your black book should be a showcase of your ability—almost a portfolio.

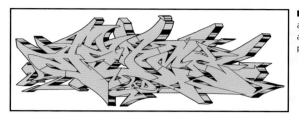

Left Play with grayscale and shading in your book, and finish off with a black pen outline.

Drawing in pencil, you can keep adding or taking away until you come up with something you're happy with. Sketch very lightly as you will want to erase anything you don't like. When you are happy with your piece, carefully mark out your perfected piece with a black fine-liner pen. Be careful not to smudge the page. When your sketch is dry, erase all pencil lines from your piece, leaving you a clean black and white image.

Applying color to your sketches

These sketches are initially a plan or a smaller version of the piece you want to put on the wall. This is a great way to learn about how colors work with each other, and which colors fade well into each other. Color is very important, so try and color your sketches thinking about fades and tones, as you would on the wall. Pantone pens and markers are good for this (see page 25), as they have real shades that fade together. Paint pens are always a special addition to your colored sketch as you can add highlights and other extras straight over the top giving them real graffiti effects.

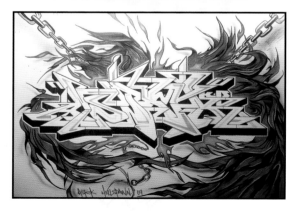

Left On paper you can afford to be more experimental with other design elements, such as feathered backgrounds.

How to trace into your black book

Step 1: When drawing graffiti you can end up with a messy image with lots of pencil lines and eraser marks, so when you have a sketch you are happy with, trace it into your black book for perfection.

Step 2: You will need some tracing paper, a pencil, and eraser to keep your pencil sharp for accurate lines.

Step 3: Start tracing your image, leaving out the parts you do not want.

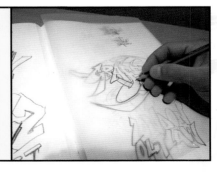

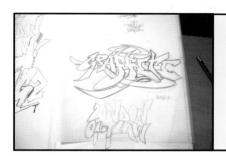

Step 4: You can stick your image down with tape, which will help you outline the entire image.

Step 5: If you want to add something to your sketch like a character, you can trace it onto the same piece of tracing paper.

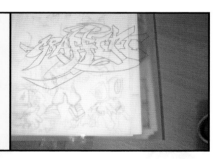

Step 6: To trace into your black book you must reverse your tracing paper and place it into the position you want.

Step 7: Draw over the reversed lines of your piece, and reposition your tracing paper again for the character to achieve balance.

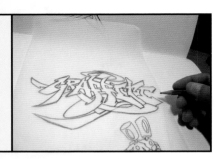

Step 8: Now you have your faint but perfect sketch, with characters perfectly positioned and balanced. If any parts have not traced, add lightly with your pencil.

Step 9: Starting at the beginning, carefully outline your piece using a black fine liner. Be careful not to smudge your lines.

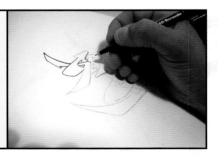

Step 10: When complete, give your image a few minutes to dry and erase all pencil lines.

Step 11: Your black book sketch is complete. Try re-outlining the perimeter of your letters to give extra boldness.

Canvas preliminary work

Paint pens are great for graffiti on canvas. Lots of artists use spray-paint backgrounds with paint pens on top, especially when it comes to a smaller canvas size. This is called mixed media. Use any paint application you want to achieve your goal. Spray paint is good on large canvases. Artists rarely attempt to use spray paint on a small surface. Some see it as a learning curve to develop precision in their can skills, but to get really creative on a small-scale, paint pens are the best.

Left This background canvas is a great starting point, as a fade has already been successfully achieved using spray paint.

You can use a ruler for super-sharp lines. You can also use masking tape to tape off sections for added effects. Artists use special techniques with spray paint on canvas, such as spatter and drip effects.

Right Astek's "Burnin' Hearts" black book sketch, 2008.

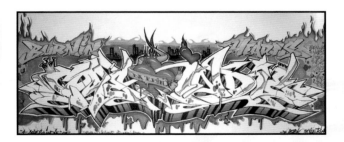

TIP:

Most graffiti artists steer away from stencils, as graffiti is a freehand art form, but on canvas stencils are used if needed.

Above Some artists successfully combine stenciling and spray paint.

Stencil preparation

Street artists apply graffiti by using stencils. Even with the most detailed image to spray, a stencil can take just seconds to paint, as all of the work is in the preparation. Lots of stencil graffiti artists use images from life and current affairs as a way of connecting with the public and drawing attention to their work. Stencils are generally taken from a computer and printed out either straight onto card, or onto paper, which is then attached to card. The artist can enlarge or shrink the image before cutting their stencil.

Stencils can be a simple one-color image or in two colors, which requires two separately cut stencils layered together to give detail to your image. Any amount of layers can be used. When cutting your stencil, use a scalpel to achieve precise accuracy. The better you cut your image, the better it will look. Using gloves is best for applying spray paint to your stencil, as you will use your hands to hold the image in place. Street artist Banksy uses two-way stencils and adds freehand spray-paint effects to the finished product. This is because he is skilled with a spray can as well. Some up-and-coming street artists would rely solely on their stencil.

Above One of Banksy's most famous pieces in London, UK.

Layering in freehand and stencil

Planning and coming up with concepts is essential in graffiti and stencil art. The two-way stencil requires a first stencil, which becomes the backdrop and creates a surface for the second stencil. Similarly, a graffiti artist will use emulsion paint to create a backdrop before putting their art up on the wall. Using emulsion saves spray paint, and over the years artists have learnt to achieve great effects with it. A black backdrop can be turned into a space scene very easily by adding stars and space effects, or with a blue backdrop you could add some clouds to achieve sky.

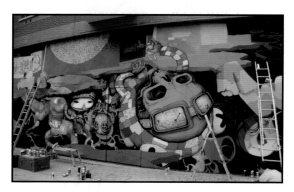

Left This DMV wall in progress has a layer of black emulsion paint as the first layer. London, 2010.

Preparing a wall with emulsion

Spray paint can be very expensive and very difficult to get hold of in some places in the world. In these places, emulsion is often used for the infill of the work and a different color emulsion for the background. Spray paint is used for the outline and highlights only. With slight spray-paint effects over the top of the emulsion, your whole piece will look spray painted. This is also a good learning curve for younger artists having trouble getting hold of spray paint. Emulsion paint can be easily mixed to create different colors, and can be watered down to a thin consistency to make it stretch. This is only a backdrop so it doesn't need to be expertly applied. Some artists will cover the entire backdrop with different layers of paint, whereas others will leave some of the backdrop around their work.

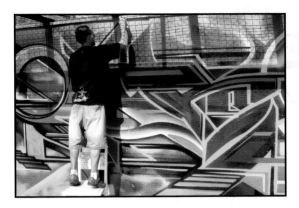

Left A large wall in process. It helps that the wall has been primed first with emulsion to avoid any changes in texture or dark marks showing through.

With an unprimed brick wall, emulsion is essential as the spray paint sinks into the brick making the colors look dull and washed out. Spray-paint technology has come a long way, and some paint brands will go straight onto the brick wall without fading. Only certain brands and colors can do this however, so emulsion is nearly always used.

Above A primed wall, ready for a new piece of graffiti art. If you are working on a crew production you need to cover the whole wall with emulsion. However, a solo piece only requires you to paint a section that is big enough for the piece itself.

Concepts and designs

When coming up with ideas and concepts, everything needs to be considered. The idea for the wall needs to be original, as does the color scheme for the pieces and the backdrop. The pieces will be colored using certain tones to make them stand out from the background. If the concept involves other artists, you need to work together to apply emulsion. Rollers are used for this, and can be attached to extension roller poles to reach high up and cover large surfaces quickly. Brushes are used to fill in any bits a roller cannot get to, like indentations in the wall.

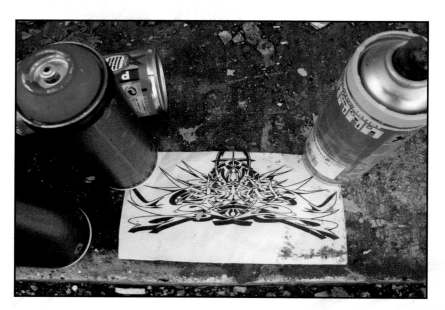

Above All graffiti artists follow a clear sketch before embarking on a large wall piece.

Left The outline is in place.

Left The second color added.

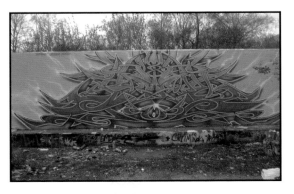

Left The third color, and outline, has been sprayed onto the wall. The piece is complete.

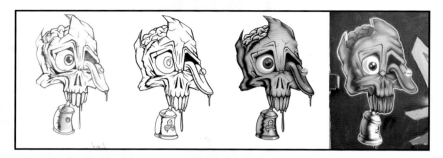

Above A character's development from (left to right) sketch, to ink, to Photoshop, to spray.

Digital creations

Many artists use Photoshop for graffiti. The stencil artist will always be computer-minded, and in some cases the digital aspect is part of stencil art's appeal. The stencil artist will use Photoshop to resize photographs and create their own images. It is easy to simplify a piece into a stencil format (see the project on pages 161–3).

Above Graffiti artists use images and adapt them to be suitable for stencil work.

Graffiti artists who paint photo realism will always use a computer to source, resize, and distort their images. All graffiti artists use Photoshop to join their pictures together, when a large piece has been photographed and also for touching up photographs. A graffiti artist will test out concepts and ideas in Photoshop, even rendering a character or a piece prior to painting it. Most artists learn to create graffiti on the computer to develop ideas with greater scope than starting on paper, and increase their technical skills.

Below Before embarking on projects on this scale, follow the exercises in this chapter to ensure your project will work.

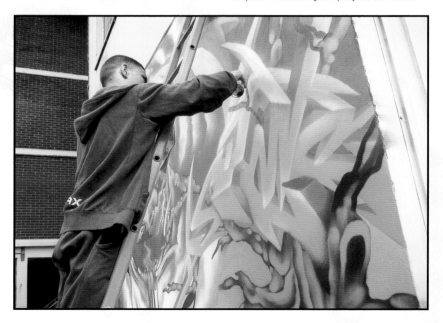

Wall etiquette

Graffiti artists do not have many areas to express themselves, and will protect their walls by teaching younger artists not to spoil or ruin graffiti art, and will also fix any cracks or damage to a wall to keep it smooth and flat. These places to paint are usually in public and are very sought after, so the artist will take that into consideration when planning their concept. Graffiti is for everyone and artists do not want to offend, they want to inspire, and for their work to be accepted by the public. Concept walls are mainly painted by graffiti crews, or friends all working together to reach a certain goal. They are also painted at graffiti events and festivals where artists are brought together from all over the world to share different styles, and to produce unique collaborations.

Below Graffiti artists take the use of permitted walls seriously.

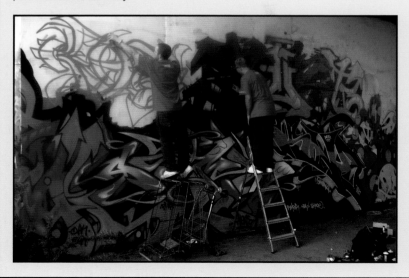

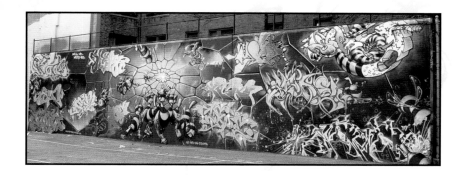

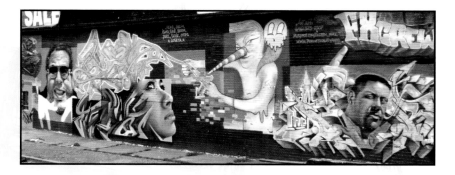

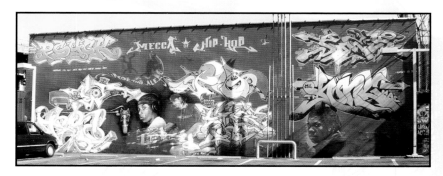

Huge concept walls created by crews in New York City. **Top** "Funky Bees" by the Wallnuts Crew; **Center** FX Crew; **Below** Mac Crew (from France) featuring Cope2.

Chapter 5

Lettering

Graffiti originated as a way of writing messages, displaying characters in an inventive and previously unseen way. Now, graffiti involves a lot more than simply characters and letters, but all graffiti artists should be skilled in rendering characters in the traditional way. This chapter will show you how.

LETTERING

Graffiti art has evolved into many new forms including 3D lettering and photo-realistic images, set on striking and inventive backgrounds. Traditional graffiti was about the letters and characters. Artists painting pieces in the 1970s took inspiration from fantasy comics by people like Vaughn Bodé for the characters, and possibly psychedelic album art from the same era for the letter formations.

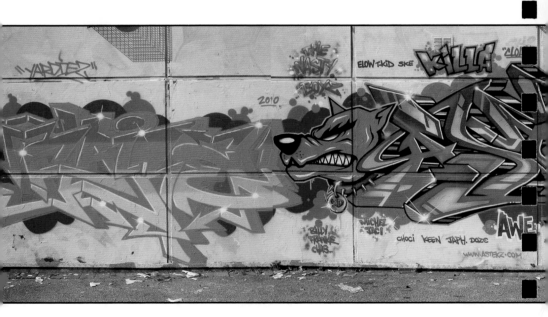

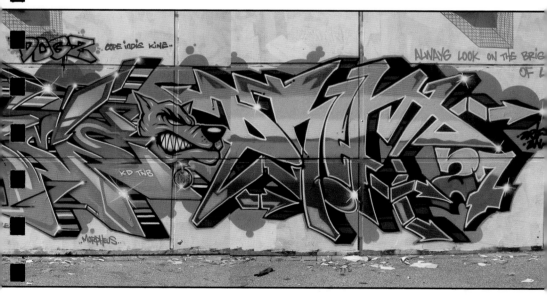

Above Fugi, Astek, and Drift's collaboration shows 2D, 3D, and wild style influences.

Bubble/Throw up

The bubble letter came soon after the first tags appeared on the trains in the Bronx, New York, by artists like Super Kool 123. The bubble letter was easy to do, effective, and most of all very quick to throw onto a wall or train. This became what is known as a "throw up:" a quick and simple piece either done in one color or two. The two-color throw up consisted of one color quickly applied for an infill, then the second color to outline.

Left Indie and Cope2's throw up lettering, London.

Left Cope2's throw up in a black book.

Throw ups became very popular and still are today. Most artists have a throw up and usually keep the same one; artists like Cap from the Bronx are famous for their throw up alone. Another artist, Cope2 from the Bronx, also was given his throw up style by Cap. Cope2's is now the most iconic throw up in the

world, there are not many people or places around the graffiti world that haven't seen a Cope2 throw up. Throw ups can be painted in any color, and are used for impact and repetitive placing. Many artists choose silver or chrome paint, painting the infill silver and the outline black. This has been made popular by the brightness and covering capabilities of chrome paint. Chrome paint needs no primer, and large areas can be covered very quickly. The throw up is still a big part of graffiti art and always will be.

Left Kie throw up with chrome details.

TIP:

Fat caps (see page 25) are nearly always used on chrome paint.

Left Cope2's throw up on a wall in Berlin.

How to draw a throw up

Step 1: Sketch out a bubble letter, keeping the edges rounded and your letters balanced.

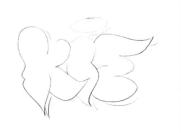

Step 2: Start to add style by adding sharp points to the bottom ends of your letters.

Step 3: Add more sharp points, trying to make each letter flow and work together, disguising your letters. Your throw up is unique to you and does not need to read easily, but does need to be repeated with ease.

Step 4: Practice your throw up. You should be able to reproduce your throw up in any medium.

Step 5: Throw ups are usually in two colors—one inside and one for the outline. I have colored this quickly, as a throw up should be done.

Dub

As the throw up evolved, it became neater and more precisely painted. It evolved into what is known as a dub or dub-style. The dub is also a two-color piece, and silver chrome is the choice color to use. Dubs are mainly outlined in black, but look great in any color. The dub is a progression of the throw up but doesn't mean the throw up is void, instead it's what gives the throw up its identity and separation from other styles. Like throw ups, dubs are painted quickly and are used for streets and tracks more than anything else. A dub can be simple or slightly stylized. Usually a bottom-heavy letter style is used. The cracked effect is very fitting and widely used for dub style. A huge dub is called a blockbuster. Blockbusters were originally painted in chrome paint and this style can still be found, but more and more artists are using emulsion

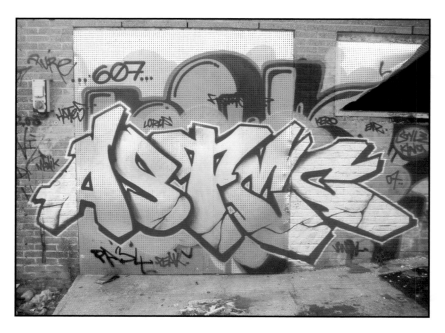

Above A silver and blue dub piece by Astek.

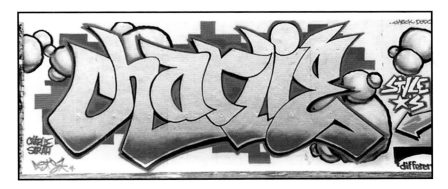

Above The dub is a progression of the throw up, as lettering becomes more sophisticated in form, 1998.

paint and paint rollers to cover the biggest area they can before adding the outline in spray paint. 3D can be used on dubs or a quick drop shadow to give each letter a lifted look.

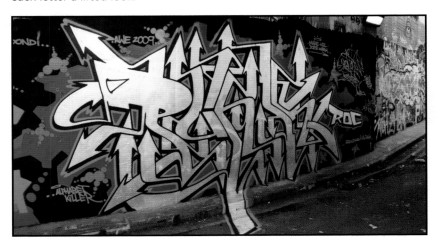

Above A punk dub by the graffiti artist Keen.

How to draw dub-style

Step 1: Dub letters are almost standard letters in style, so sketch out a basic block-style piece.

Step 2: Over the top of your block-style, elongate your letters and make them bottom-heavy. Push your letters together and curve them, making sure each letter is created in the same style.

Step 3: Trace your new outline or erase any unwanted lines.

Step 4: Dubs usually have a drop shadow rather than a 3D block. Add your drop shadow.

Step 5: Blackout your letters including the drop shadow.

Step 6: Dubs are usually in two colors. The border should be done in the infill color and some extras like dots and stars can be added to the border.

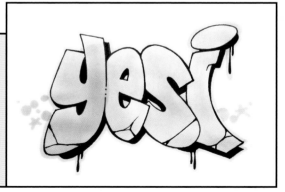

GRAFFITI-STYLE

Flat 2D piece

A lot of different styles were experimented with early on in graffiti, but it is the 2D or flat piece that most people recognize as graffiti. 2D is as fresh today as it was in the early days—it has evolved and been perfected. Some graffiti purists, such as Can2 from Germany, only paint 2D and don't want to move into other styles, however influential the new styles are.

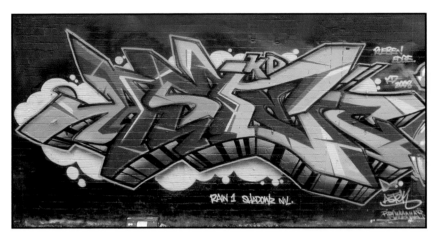

Above Some 2D artists add a 3D block to help it to pop from the wall.

Below 2D from the Dutch Graffiti artist Does.

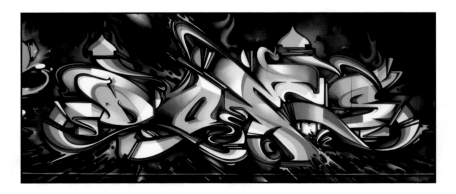

Artists like Dare from Switzerland have probably taken this the farthest by creating many 3D effects for the 2D piece. A 2D piece is made to look 3D by adding a 3D block to give depth either to the side of your letters or at the bottom. The top of the 3D block can be colored and is part of the outline. Stripes inside the 3D block are popular, and give the 2D piece a great 3D effect. 2D pieces can be simple or complex.

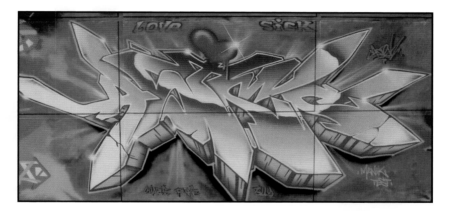

Above A complex 2D piece is also known as a semi-wild style, which is when your letters are wild but not connected, and usually quite easy to read. This piece by Astek makes use of the chrome effect with shades of color.

GRAFFITI-STYLE

A stylistic dub with a full-color infill could be seen as a 2D piece, but the work involved and applied defines which is which. There are styles within styles in 2D, for instance the digital rock style or computer rock style pioneered by famous graffiti artist Case2 from the Bronx. Artists like Keen1 from London have pushed this style to new levels by using straight and sharp lines with equally sharp infills. The digital infill replicates computer imagery like circuit boards and graphics. This infill can be done in any color. Choice colors to use for the infill are dark shades of brown, or purple with digital lines and effects in greens then outlined in a light outline color.

Other styles in 2D are the Bronx style that has been pioneered by artists like Billy167 and Seen. Starting in the Bronx, this style quickly spread across the world. This style is similar to digital but uses curved lines and clever connections. Artists like T-KID from the Bronx combined the two styles to produce his own unique technique with amazing results. Backgrounds for 2D pieces are quite simple normally. A cloud or splat is used, unless it is part of a production with other artists, then all the background would be the same for each artist to show it's a production or collaboration.

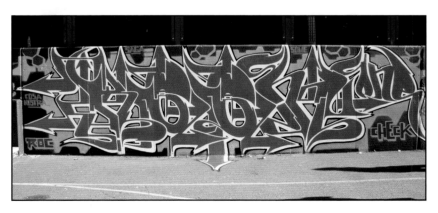

Above A 2D piece by Keen.

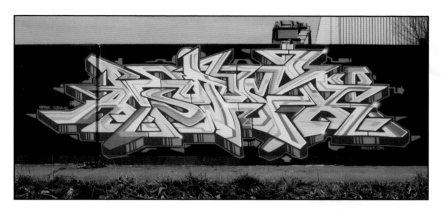

Above An Astek 2D piece, 2006.

Above Does Maaseik,
Belgium, 2010.

How to draw a 2D piece

Step 1: Sketch out your piece in a light pencil.

Step 2: Add more style to your letters, including arrows, cuts, and slices.

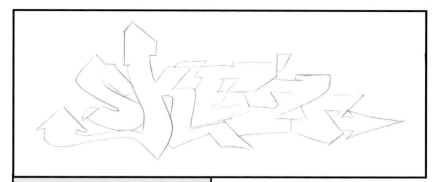

Step 3: When you are happy, you can either trace your sketch or erase any unwanted lines.

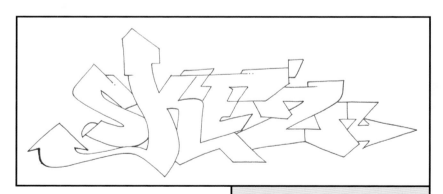

Step 4: Black out your image and erase any trace of pencil.

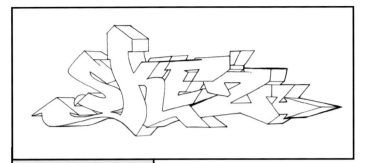

Step 5: Add a 3D block to your 2D style.

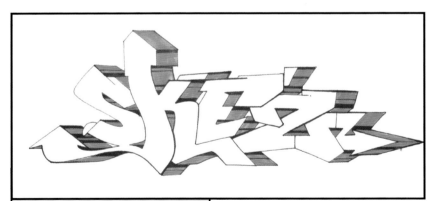

Step 6: You can add stripes to your 3D and can add a shadow where your letters overlap.

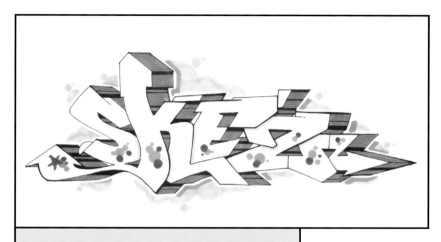

Step 7: Add some dots and stars to your infill and your cloud to the background.

Wild style

The natural progression from a complex 2D piece or a semi-wild piece is the wild style. Wild style is the core of graffiti art, and only experienced artists can paint in this style as it takes a lot of practice and the technique is developed and honed over time. A completed wild style is also called a burner.

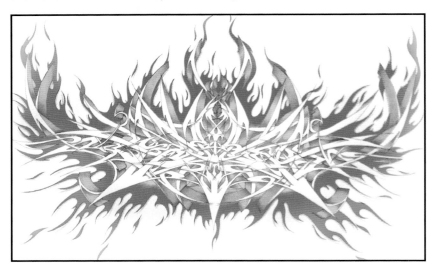

Above A wild style piece that uses paint pens on paper.

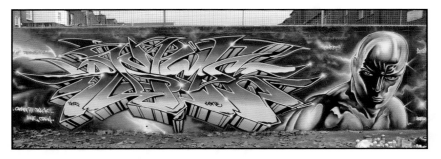

Above Astek wild style, London 2010.

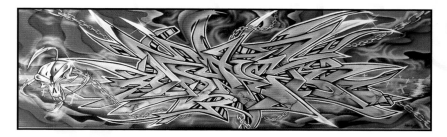

Above A wild style on canvas.

Wild style is how it sounds: making your style wild, unreadable, and complex. Every letter should connect to the next letter with flow and ease using clever connections. To a novice or a new artist, wild style would be unreadable. Only other artists will be able to read or decipher your piece. Artists work on a wild style outline until it's ready to burn, adding more and more connections. Flames and fire effects work well with wild style, as you are painting a burner the more heat in your effects the better.

Wild styles can come straight out of the ground, losing the bottom of your piece, can be floating across the wall, or even stretched or morphed into any shape you can think of. A 3D block is always used on a wild style, sometimes with stripes inside like the 2D piece, or a more advanced effect like a warm glow. The 3D block can go in any direction to give added effect. Color in a wild style is very important. A wild color scheme can add complexity to your style. By using colors close to your outline color your infill effects will cut up the style even more. All effects can be used here, the more the better. Wild style is only for the experienced painter, so all of the effects will be easy to apply by the time you are ready to paint a wild style.

Inexperienced artists should practice wild style on paper and in their black book. Try making the letters of a semi-wild piece connect together to achieve a wild effect, then try adding some arrows. You can use tracing paper to add more connections and look at what looks good before adding it to your sketch. Tracing paper is great for making sure your letters look similar. Design a wild letter and then put tracing paper over the top and try and change your letter to another, keeping as much of the original letter as you can. Moving the tracing paper around helps to make things fit a little better. Lots of wild-style painters like symmetry in their style, and tracing paper is sometimes used for this. You can experiment with this, introducing symmetry by making the beginning of a piece mirror the end. Using the same arrows either side adds to the symmetrical effect.

Above A wild style sketch, which mirrors perfectly.

Wild style requires more than clouds and splats, instead try lightning bolts hitting the edge or breaking through the wall. Lots of artists use flames in any color. Your wild background would usually be symmetrical as well as the piece. Wild style stands alone unlike any other piece, because wild style dwarfs any other style and commands more space on the wall, and basically makes other styles look inferior. For this reason, wild style stands alone. Some artists around the world (like Saber from USA) spend days to paint the biggest wild styles and fill one wall, which would normally take five smaller pieces.

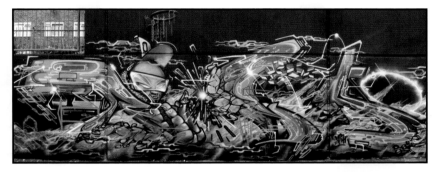

Above A wild style piece by the graffiti artist Bonzai, London 2010.

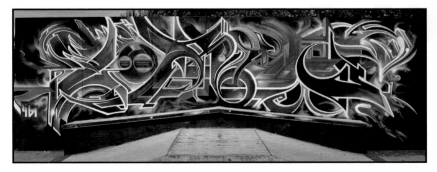

Above A wild style piece by the graffiti artist Loras.

How to draw a wild style letter

Step 1: Take the basic shape of the letter A and sketch it out in a light pencil. Keeping the letter structure, slightly bend or curve the bars of the letter giving it style and flow.

Step 2: Still with a light pencil, open as many avenues for connections as you can. A connection can go anywhere on the letter. Also add a step or a flick to some ends of the letter.

Step 3: Darken the letter with the connections you're happy with, and erase any unwanted lines. Do not close openings.

Step 4: Add two to three arrows to your letter (see Arrows on page 63).

Step 5: The other open connections would be closed off or joined to the next letter on a bigger piece. As this is a single letter, they will all be closed with one of many techniques such as a slice, a rounded slice, or a slick or sharp point. Add these to the remaining open connections.

Step 6: Now erase any lines you're not going to use and darken the arrows and the ends. If all joins and connections meet and you're happy, carefully go over with a black fine liner, and let dry for a minute. Erase all traces of pencil, and add drop shadow or 3D (see Shadowing, pages 60–2).

3D lettering

3D graffiti is generally known as the newest style of graffiti, and is being pioneered by artists like Delta from Holland and Loomit from Germany, who heavily pushed 3D graffiti in the mid-1990s.

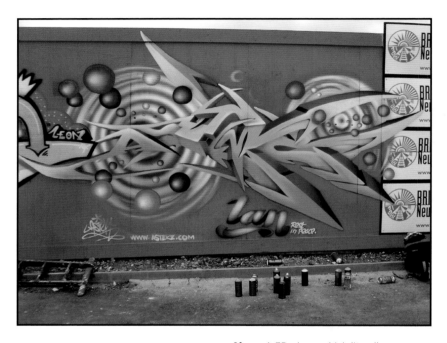

Above A 3D piece, which literally pops off the red background. Astek uses complementary colors (page 186) to great success here. London, 2006.

Like all graffiti, 3D was painted first on the Bronx subway trains by true pioneers like Flint707 and Pistol Pete. Defiantly before their time, these artists filled whole trains with 3D burners. 3D started and stopped with these artists, until Delta and then Loomit picked up on the style, reworking it into what we see today.

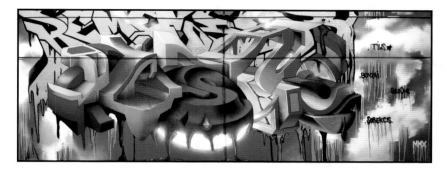

Above A 3D-piece called "Remember Jesus" by graffiti artist Lovepusher, London 2010.

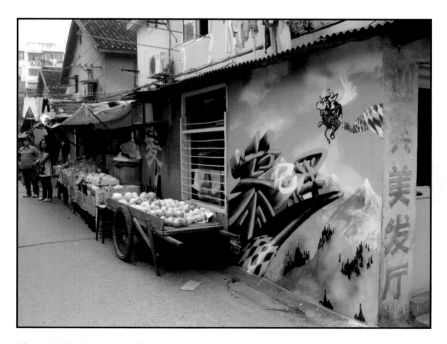

Above A 3D-piece by graffiti artist Loomit.

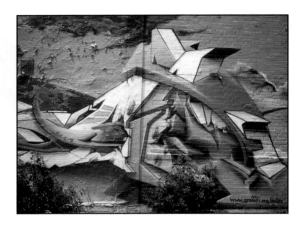

Left A 3D piece by the graffiti artist Daim in New York.

European artists heavily followed the new 3D style, spawning great 3D artists like Daim and Seak from Germany. The basics of 3D pieces are that they have no outline and are painted in tones of the same color to produce the 3D effect.

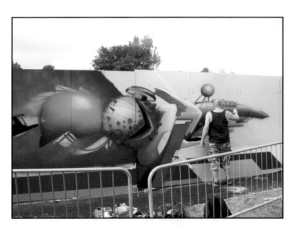

Above Graffiti artist Seak paints his 3D style.

TIP:

A 3D piece will be very hard to achieve unless you have perfected all other styles. When your 2D or wild styles are polished and tidy, you are ready for 3D.

How to do a 3D piece

Step 1: Sketch out a block-style piece in a light pencil.

Step 2: Separate your letters and make each letter sharp.

Step 3: Add a 3D block to the sides of your letter making your letter resemble a cube.

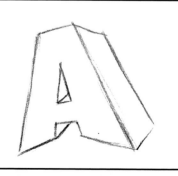

Step 4: Try the same with your other letters.

Step 5: When adding your 3D influence, try and keep the 3D angled and sharp.

Step 6: Try changing the angle of your letters.

Step 7: Add 3D effects.

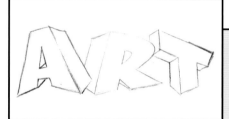

Step 8: Now sketch or trace your letters out and put them together.

Step 9: Try to enhance the 3D influence by adding more dimension to your style.

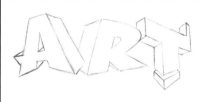

TIP:

3D is the furthest a graffiti artist can take style, and takes a lot of skill to paint. Most artists would not paint 3D until they have really learnt how to paint with a spray can, and are fluent with 2D and wild style. 3D graffiti can be practiced for years before some artists are ready. Jumping feet-first into 3D could work, but you will be bypassing the basics and you will never learn to paint an outline, which is the essence of graffiti.

Step 10: In pencil, shade in the areas that would be darker. Keep the face of your letters light and shade the sides. As one letter overlaps another needs a shadow to be added.

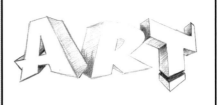

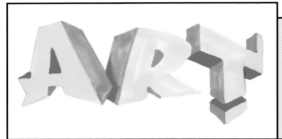

Step 11: Three colors can break down the way 3D colors work, before you try the standard nine colors (see Tip on page 115).

Step 12: Adding a background to a 3D piece is key to making it work and will help your 3D style jump off of the wall.

TIP:

Three colors can produce the 3D effect, but if you were going to paint a 3D piece, start with as many shades of the same color as possible (about nine shades is the professional minimum) to create the sides and the front to your 3D. This is because you can use four darker shades to paint in the sides of your letters and four lighter shades for the front or face of your letters. The final color is used as a background as well as to sharpen up your letters.

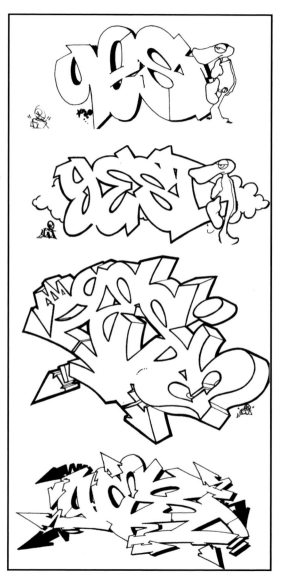

Right These sketches by graffiti artist Yesi show how a style progresses from bubble, through to 2D, 3D, and wild style.

Tools of the trade

Some artists sketch in 3D for a long time before taking on an actual 3D piece of graffiti art. 3D involves using light and dark to make the effect look real—to achieve this you imagine a light source coming from an angle to define where the lighter and the darker shades go. Paint brand Molotow by Belton have pushed 3D art in a major way, with the help of the artist Loomit. Loomit was invited by Molotow to produce a paint and cap system for slow pressure, which has all shades for the perfect 3D painting. Other brands like Montana have also produced a paint range containing every color shade. The slow-pressure cap system sprays a clean line with a clean edge, which is a big part of 3D. The banana cap by Belton was the first cap to do this. Now any soft or skinny cap works in the same way.

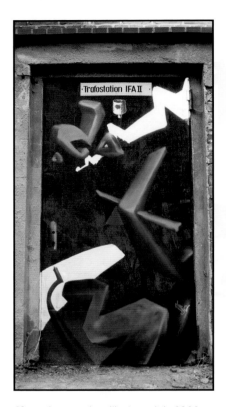

Above Some artists, like Loomit in 2008, decide to use everyday backgrounds in their work.

Now used worldwide, 3D graffiti has no boundaries and can be wild and sharp, squared-off like machinery, or robotic with very clever letter connections. 3D is painted with more care than other styles, as it needs to be clean and tight right away—unlike a 2D style where you can neaten it all up at the end.

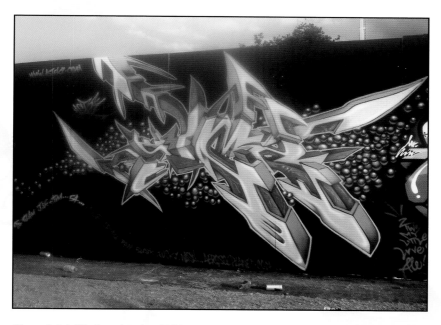

Above Astek 3D piece, London 2006.

Background choices

Applying different shades takes time. When completed, you can sharpen or clean the edges and points with the background color. You can use an emulsion backdrop and match a spray paint to the emulsion to clean the letters by removing anything unwanted. This is even easier with a spray-painted background. When cleaned up, your 3D piece should be as polished as a computer graphic. The 3D look commands a scenic background in a way, as 3D pieces often look like they're flying, floating, or robotic. 3D will look something like a spacecraft. 3D backgrounds are much more advanced than other styles.

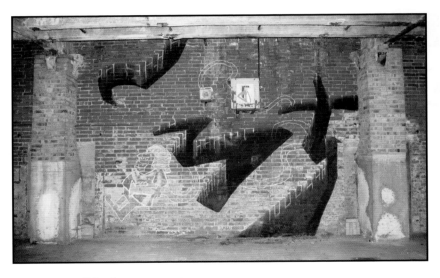

Above The graffiti artist Loomit has let the brickwork show through in a modern approach to 3D graffiti, Germany.

TIP:

Some artists paint and push all styles and are known as all-rounders or as style kings. As you move through graffiti art you can do the same, but start at the beginning and work your way through, conquering each style in your own time.

Using canvas

3D on canvas has a totally different look to other styles on canvas. Any other style would be classed as graffiti on canvas, whereas 3D is more akin to fine or abstract art. This has helped graffiti art become more accepted as a legitimate art form. Graffiti art in 2D and 3D is commonplace in art galleries all over the world. Some of the pioneering graffiti artists like Delta have a major following with galleries, selling work to order. Other pioneers of 3D like Seak have managed to push 3D even further. Seak is known to have the most advanced take on 3D in the world. Both Seak and Daim have had sculptures made of their pieces, and specialize in all things 3D.

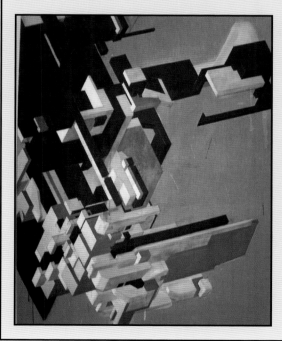

Left Graffiti on canvas, Delta, London 2005.

Chapter 6

Characters

Now that you have conquered lettering, it is time to focus on the characters that form a huge part of the graffiti esthetic. In this chapter you will learn how to develop the drawing skills that will help you to create outstanding graffiti characters.

CHARACTERS

Characters are a big part of graffiti art and accompanied the first ever pieces. In the early days of graffiti, characters from everyday culture were very popular, such as superheroes like The Silver Surfer, the Thing from *The Fantastic Four*, cartoon characters like Mickey Mouse, and Donald Duck.

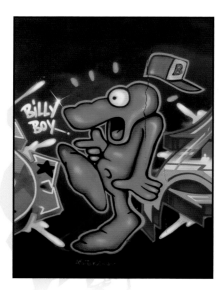

Left Astek's Billy Bode character.

These images were head-turners and became essential in graffiti. Artists have long found inspiration in the characters they liked as they grew up. Artists had fun with this concept, using Smurfs and gun-wielding dinosaurs. There were also classic characters like Vaughn Bodé's lizard men and Cheech Wizard, who is still much admired by artists because of his activities and anonymity. Artists popularized Cheech Wizard and helped spread interest in Vaughn Bodé's fantasy comic art all over the world.

Right Ghetto blasters have long been associated with graffiti imagery. Tizer character, 2005.

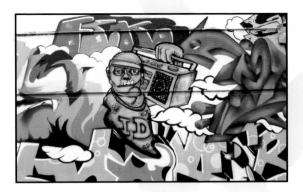

Not all characters were copied from other sources. Even in the early days, artists like Blade from the Bronx were very inventive, and famous for whole-train pieces and crazy characters. The first graffiti character was a side profile of a guy with an Afro, and others emulated this character and put their own take on it. These characters are known as "mugsies," and artists like Cliff Phase2 and Stop700, from New York, are credited for being the first to paint them.

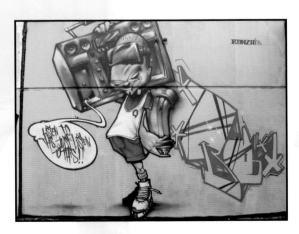

Left A graffiti character by Bonsai.

How to draw a simple face from side profile

Step 1: Sketch out a side profile with all the features. Beside this, redraw the side profile, this time simplify, straighten and exaggerate the shapes of the features.

Step 2: Add the eye and a simple line for the cheek. For a popular graffiti style, the eye could be a slick line. Exaggerate the eyebrow, making it more angular.

Step 3: Add a line for the mouth and a chiseled cheekbone line.

Step 4: Add the hair and the shape of the head. Keep the hair and head sharp. By creating a slim neck you can help to exaggerate the wiry, chiseled features. See page 129 for more exaggeration tips.

Step 5: Add more expression to features. To create a surly expression, focus on the mouth by turning down the mouth line and extend the line underneath the bottom lip. A similar technique can be achieved for creating a pout.

Get the basics before you get creative

Graffiti is known for its personal take on the figure, and sticking to traditional notions of artistic form may seem irrelevant, but once you have these down your characters will soon begin to look like the realistic people you want them to be.

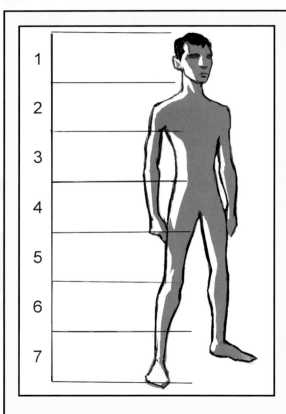

Proportional figures

Using the head as a unit of measure, the average human's proportions are seven heads in height. This measurement only works if the human is standing upright and is being viewed at eye level. Any variation in pose such as crouching or sitting will not follow this proportion rule. If you would like a character to look imposing or heroic, you could increase the head count to eight heads.

How to draw a face

Step 1: Start with a simple oval. It gives a good starting point for the taper of the face.

Step 2: Find the center and draw a line down the middle vertically. Halfway down, draw a horizontal line to indicate where the eyes will be.

Step 3: About halfway between the eye-line and the bottom of the chin, indicate a line for where the nose will go. With that line established, now draw a line halfway between the nose-line and the bottom of the chin, to indicate the mouth placement.

Step 4: Draw the lines along the eye-line. Imagine that the line would be going halfway through the eyeball. The space between the eyes should be the length of one eye. To indicate the width of the lips, find the corners of the eyes, and draw vertical lines down to the previously placed mouth-line.

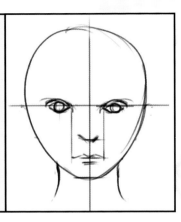

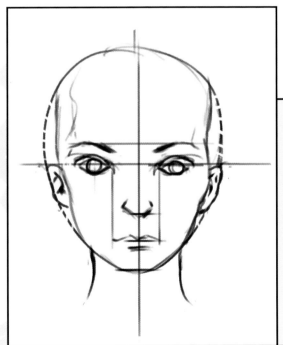

Step 5: Approximately ²/₃ of the way between the eye-line and the top of the head you can place the eyebrows. Indicate cheekbones, the overall shape of the forehead, and the jaw-line. The top of the ears should line up with the eye-line.

Change the features

You can exaggerate a character's ugliness by making features grotesquely disproportionate. Scale can also be used to adjust a character's physical importance. Graffiti characters are usually quite devious looking. To achieve this effect, sketch the eyes and draw them on an angle, exaggerate the eyebrow and try a simple line for the mouth.

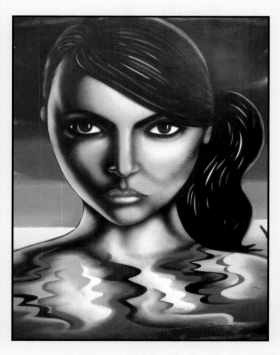

Left Working with light and dark can help in your quest to achieve expression and emotion in graffiti work. Astek, 2009.

How to draw graffiti hands

Hands are notoriously difficult to draw, and a lot of practice is needed.

Step 1: Sketch out the back of the hand.

Step 2: Try folding two fingers, so you're left with two fingers up and two down.

Step 3: Try and fold all the fingers and tuck in the thumb to create a fist.

Step 4: Sketch the front of the hand. Add the finger lines to the hand and define the palm with two curved lines.

Step 5: Fold three fingers down, leaving one up to create a hand pointing.

TIP:

Hands are difficult and need lots of practice. Try looking at comics and cartoon characters.

Step 6: Fold all the fingers and tuck in the thumb to create the front fist.

Foreshortening

When an object or form is moving toward the viewer, creating an optical illusion, foreshortening is used. This is particularly important in graffiti because so much focus is on 3D work. Foreshortening can be tricky, as forms get distorted and do not appear as we expect them to. If a foot is coming at us, the foot may appear very large, while the legs—usually the longest part of the body—appear short.

Above Practicing with cylinders, and simplifying shapes, is a good way to start when working with foreshortening.

How to draw a can in a hand

Step 1: Sketch a spray can at an angle.

Step 2: Add three ovals for the first three fingers. Try pairing two fingers together and leaving one at a slight angle.

Step 3: Add the forefinger so it's pressing the cap, and a small oval for the thumb at the bottom.

Step 4: Add the fingernails to the fingers, and erase all unwanted lines.

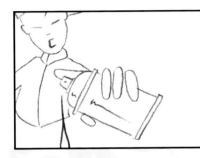

Step 5: Attach the can in hand to a character.

Alternatives to the can

If you decide not to sketch the can, there are some fun alternatives to try. Remember the foreshortening rule also applies to these.

How to draw a reaching hand

Step 1: A hand is made of oval shapes. Lightly sketch out the oval shape and add the fingers.

Step 2: Now you have the basic shape, sketch around the hand, defining the palm.

Step 3: Erase all unwanted lines and add the finger lines. You can add one or two palm lines.

B-Boy characters

As part of the relationship with breakdancing and hip hop to graffiti scene, the B-Boy became a common character, always wearing the coolest get-ups. A favorite of B-Boys were sky goggles. From these early characters the mugsie lived on, and is part of the Bronx style. These characters were also used to replace letters, adding style to their pieces. The side profile was also important in character painting. As the new styles traveled across the world the characters evolved. Side-profile characters were used all over, especially in London, where astronaut characters became a big phenomenon.

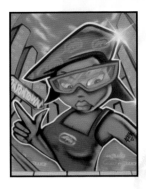

Above Note how effects like highlights can be relevant to characters, as well as lettering styles. Astek, 2009.

How to draw a B-Boy character

Step 1: The B-Boy stance is quite distinctive. Using a 2B pencil, sketch the character's head tilted to the side. Add in the body in a pot-bellied style with an arching back. The legs will be almost opposite the body creating a bowed-leg look. Shoes and trainers should be bottom heavy and exaggerated in size.

Step 2: When you are happy with the character's stance, start to add more detail to the clothing and figure. Don't be afraid to experiment in pencil, and erasing as you go until you have a figure you are happy with.

Step 3: Complete all details of your character, including the face and expression.

Step 4: Using a black pen, begin to outline your character. Add bits of extra detail as you outline.

TIP:

Only quality pens can produce skin tones. Try leaving small parts white to give a highlight to the skin tones.

Step 5: Using two tones of paint pens, add skin tones to the face and hands.

Step 6: To color the jacket, use three shades of the same color paint pens. Start with the darkest shade and color the edges of each section. Add color to the rest of the jacket.

Step 7: Using a lighter shade, add more color to inside of each section of the jacket. Leave some white in each section, as the build-up of the three tones creates a 3D puffy-style look.

Step 8: Using the lightest shade you can now color and complete the jacket.

Step 9: Add some gray texture to the fur and to the goggles using the mid-tone of the jacket infill.

Step 10: For the jeans, try using two shades of blue paint pen. Using a dark shade, color the edges of the jeans.

Step 11: Using the lighter shade of blue, color the jeans. A bright color will work if you blend the shades in well. Add a gray outline to the shoes leaving lots of white space.

Step 12: Add some color to your character's accessories. A matching color, like this vibrant red, always works well.

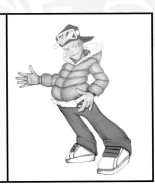

Step 13: To define the character more, outline again in black fineliner and add more detail to the jeans and the face.

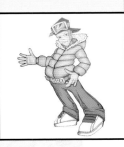

Step 14: Add some highlights in a white paint pen. You can also border your character using a complementary shade. Add a subtle shadow using a gray paint pen.

How to draw a B-Girl character

Step 1: Using a soft 2B pencil, sketch a face shape on a slight angle, using the proportion rules of the face project on pages 127–8.

Step 2: Sketch in the eyes. Exaggerate the shape of the cheeks. The chin and the cheeks should form a heart-like shape.

TIP:

As this is on an angle the right side will be slightly wider, as will the eye.

Step 3: Sketch in the nose shape, the eyebrows, and the detail on the lips.

Step 4: Add some hair to the character. B-Girls are fun to sketch and paint so experiment with different hairstyles and hats.

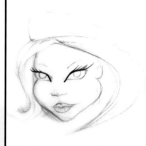

Step 5: When you are happy with the sketch, start to outline the eyes using a black fineliner pen. When outlining try to add in the eyelashes in the same stroke and lift away to create sharp lashes.

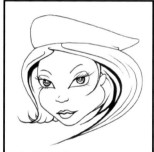

Step 6: Continue to outline the B-Girl. Heavily outline the inside of the hair to show depth.

Step 7: To achieve a realistic skin color, use three different tones. Using the darkest shade, add shadow close to the hairline and under the lips.

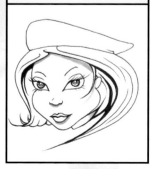

Step 8: Using a middle shade, add more color to the face, leaving the center free of color. It shows the light catching and creates depth.

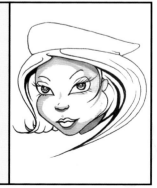

Step 9: Add some color to the eyes and lips. A lot of color here can be fun so have an experiment.

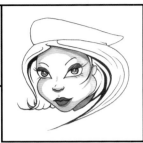

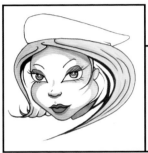

Step 10: Using two different shades of yellow paint pens, color and texture the hair. Use the lighter shade for the outside and add texture with the darker shade. Just adding lines in the direction of the hair will help this.

Step 11: Using the darker shade, color the inside of the hair.

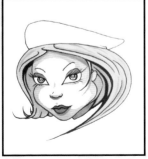

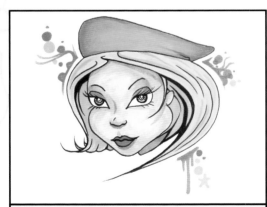

Step 12: To finish, add your lightest skin tone to the face. Add some more subtle effects color to the eyes and blend some gentle pink to the cheeks.

Character progression

In the 1990s, graffiti was going up on walls and progressing fast. Classic and traditional characters were still being used, but it was a time for the character to advance. The B-Boys and B-Girls advanced with some of the first character artists like Drome2, Moe1, and Mode2 in London.

Mode2 is part of the Chrome Angels, the UK's most influential graffiti crew, with members from London and Paris. Mode2 was also one of the first artists to add shadow and light sources to his characters. The side profile was no longer used but fondly remembered; instead they were face on and larger than life. Mode2 put a take on characters and the rest of the world followed. His work has also appeared on the cover of the book *Spraycan Art* (Thames and Hudson, 1987) spreading the word. Mode2's work constantly updates, depicting everyday life and the study of the female form.

Above This wall by Mode2 in London has influences from Japanese art and culture.

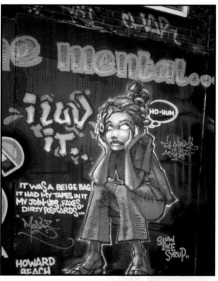

Above Mode2 has pioneered the character revolution in London from the mid-1980s to today.

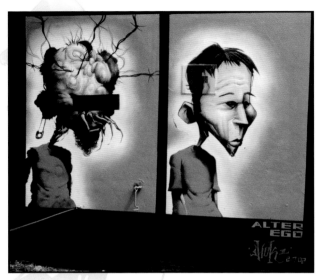

Left This character piece called "Alter Ego" by Shok1, pushes the standard of spray can technique up a notch, particularly with his use of a light source.

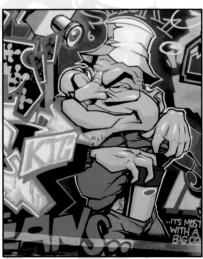

Above Shok1's unique B-Boy character.

Another pioneering character artist is Shok1, also from the UK. Shok1 is equally unique in his take on the B-Boy character. Using the greatest skill, he has crafted his own style, pushing spray-can techniques to new levels. He is another master of the light source and also one of the first artists to use it. Shok1 has set a standard for people to follow, not only with his character style but also with his accurate and clean-cut techniques. These techniques have lead Shok1 to evolve his characters and create his own organic life-form style.

Photo-realistic characters

In recent years, a photo-realistic image of a person or a creature of some kind can be used as characters in graffiti art. These are usually painted by character artists choosing to progress in this way. These artists start with realistic images and make it their style or their trademark. These images are painted in black and white or full color, with skills and techniques acquired over the years. The countless shades of good-quality spray paint available today have helped to push photo realism to the extreme, and today the most breathtaking spray-painted characters can be achieved.

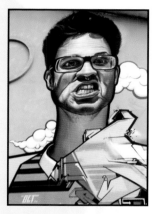

Above Photo-realistic graffiti from Belin, 2010.

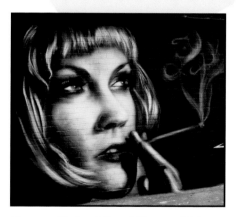

Above and below A Trans1, Ebee, and Eska photo-realistic production, London 2010.

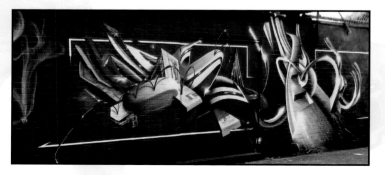

How to work in a photo-realistic style

When I painted my first ever photo-realistic image I used black, white, and a middle gray. In a more recent one I used about ten shades of color with transparent black and white. Here I have shown the most simple and effective way to achieve an image. As you learn, you will begin to add more shades. Monotones are the best place to start and real skin color tones are the furthest you can take this style, as so many colors make up a realistic face.

Step 1: Choose the image and pick out colors. Black, gray, and white are a good place to start, as are simple shades of one color. In this project we are using similar tones of green, plus a black and a transparent white. Start simply and when you feel ready, you can begin to practice with more shades.

Step 2: Prime a space. Graffiti can go over anything, but I would strongly recommend priming for this type of character with a neutral emulsion paint. If you are not happy with the image you can paint over and start again.

Step 3: Mark up the outline of the image with your darkest shade of spray paint and step back, checking the image on paper is correct on the wall.

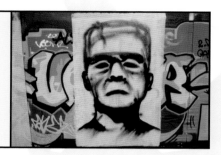

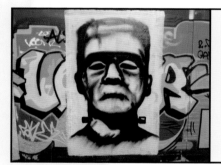

Step 4: When you're happy with the image, define the features and step back, and check again by holding up the image on paper to compare.

Step 5: Add your first shade of color. I'm using dark green dusted over black as this will fade into the black and allow you to fade in the next shade.

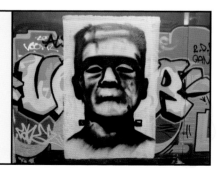

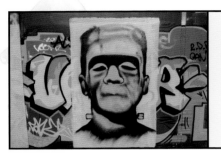

Step 6: Now start to add the next shade, fading into the dark green and leaving darker areas of detail showing.

Step 7: Angle the can inward to achieve a sharp edge on one side and a faded edge on the other. Use this technique for curved sections of the image.

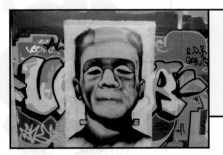

Step 8: When color is complete some of the detail will be lost. Add the lost detail in black. Again, angle the can to achieve an edge.

Step 9: Add the detail where it is needed and check the image is looking right.

Step 10: Before adding the second shade, dust the face with black from a distance of about 10 inches. Dust where shadow or darkness is required. You are adding tones to the green with this.

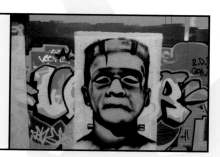

Step 11: Still using black, dust over the face using the can at different distances from the wall to achieve different shades.

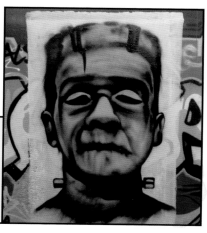

Step 12: Using the second shade, lightly add the shade to the light areas again. Angle the can inward to define areas.

Step 13: Before adding detail in black use the second shade to create sharp lines. To do this spray lines in a forward motion very quickly.

Step 14: More detail can be added by using a spatter effect. Holding the can about 10 inches from the wall, pull back on the cap and press down. Add spatter where you feel it is needed. It is good for eyebrows, hair, and stubble.

Step 15: Now add your third shade again, using a can on an angle for the edges and straight on in other areas.

TIP:

Transparent paints are available in most paint brands. They're available in every color in the Molotow brand, but just black and white in other brands like Montana. They are great for subtle finishing effects.

Step 16: Each time you add shading it can fade into the detail, so in black add the final details. Use the can in forward motion and fast for sharp lines. You can also achieve detail with dots and dashes. Add more green to remove detail or give a sharper look.

Step 17: Add some transparent white to the light areas and use the can on an angle to define parts of the face.

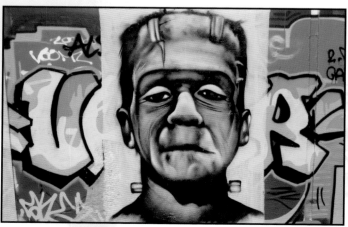

Worldwide styles

Characters today are still excelling in every direction, and like the varying graffiti styles, they're painted in totally different styles across the world. In places like Spain and Brazil, artists have really defined their own style in character painting, taking their influences from their culture and painting humble, honest characters unlike anything you will see anywhere else. Spray paint is very expensive in these parts of the world, and sometimes impossible to come by, especially for the artists from the ghetto areas, so the use of emulsion paint is quite common, with spray paint used for intricate detail. This reflects in their images and puts a refreshing take on character style.

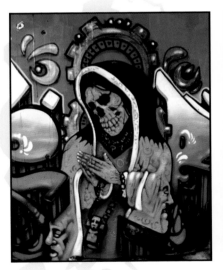

Above Spanish graffiti artist Ler, 2010.

Above Ler, 2010, Madrid.

The character artist is a vital part of graffiti art. Most character artists will come up with concepts and take on the responsibility of producing sketches and plans for other artists their working with. Letter artists will add their styles to a background controlled and designed by the character artist, and follow the concept—this kind of teamwork is the same across the world. A graffiti crew with great letter artists and great character artists would be at the top of their game and hard to compete with. Mac Crew from France are world-renowned for their character concepts and crew productions.

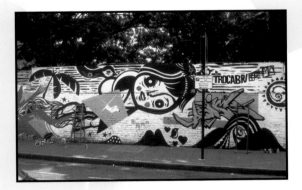

Left Brazilian artist Speto. London, 2006.

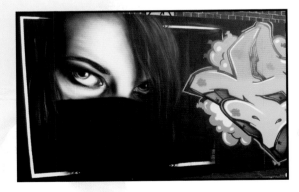

Left Trans1, London 2010.

Chapter 7

Stenciling

Stenciling is growing in popularity as part of the graffiti movement, and new techniques are being developed all the time. Discover the origins of stencil art, and learn some techniques to create and use your own stencils.

STENCILING

Part of the street art movement, stenciling is quite different to graffiti art, but is still a form of graffiti. Like some graffiti styles, stenciling has always been used but has only become popular in recent years.

The stencil was originally a simple process for people to make signs, and probably called for the use of the spray can before graffiti even existed. The first stencil I saw was in the early 1980s, it said "Jiving Instructors," advertising a group of saxophonists. This advertisement was everywhere, and illegally placed. Other organizations were also using stencils at this time.

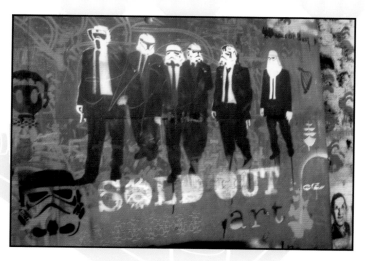

Above Anonymous stencil art, London 2010.

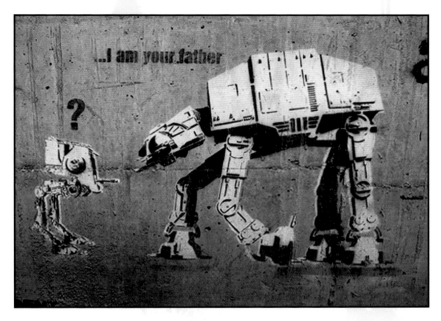

Above Anonymous stencil
art, London 2010.

The rise of stenciling and street art is largely due to Banksy, the infamous
street artist from Bristol in the UK. Starting out as a graffiti artist, Banksy
almost solely pioneered stencil art at first, using a combination of stencil and
freehand spray painting and moving onto mainly using stencils. This rise
brought many stencil artists out and started the street art movement.
Illustrators and cartoonists have also taken this opportunity to take part in
the graffiti scene.

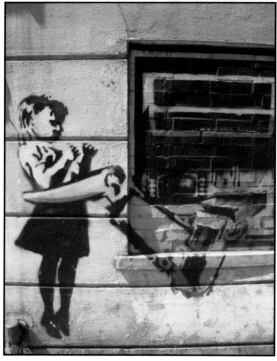

Above Banksy, London.

Below Banksy, London.

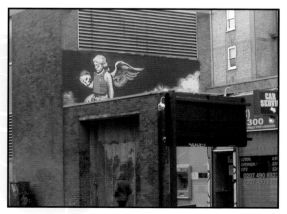

Street art consists of stencils, stickers, and hand-drawn or printed posters stuck up onto walls with paste. The movement is now huge all over the world. There were other stencil artists like Blek le Rat from France whose stencil art has been on the walls in Paris for twenty years, has been highlighted by the rise.

Below Blek le Rat, London.

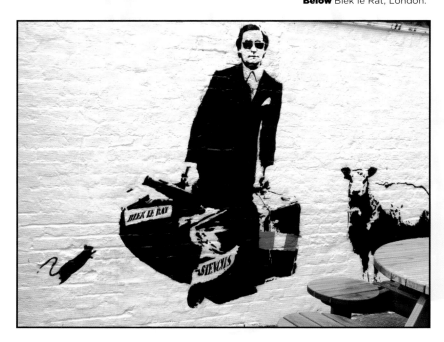

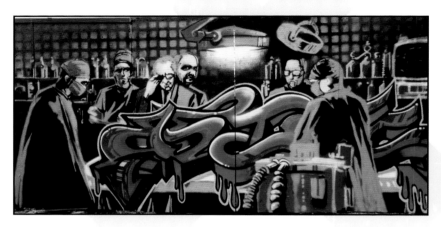

Street art vs. graffiti art

Street art has a different appeal than traditional graffiti. Traditional graffiti is mainly for graffiti artists and graffiti followers; it's part of the subculture and closed if you do not know anything about it. Street art is open, aimed at the public, and carries a meaning—sometimes political, a humorous stab at society, or just for art's sake. It is this that has given street art its wider audience. People understand it and can relate to it, and it's an easy-to-create stencil that anyone can do. The real art of the stencil is in the subject—to come up with something new—which is the same as in traditional graffiti.

Above An Astek and Banksy production, 1998. This piece is a successful combination of stencils and 3D lettering.

Creating your stencils

The computer is used for stencils to print out images and to enlarge or shrink images. A small stencil could be printed onto card and cut out, whereas something bigger would be printed out and stuck onto card using paper glue. When cutting your stencil a scalpel is the best. The better you cut your stencil, the better the finished image will be. Stencils can be made out of wood (being cut out with a jigsaw) or given to a sign writer and produced in plastic. Plastic stencils are only used if you want to make a stencil that will be used over and over again. Industries use stencils like this to label their equipment.

How to manipulate an image for stenciling

Step 1: Choose your image. Try choosing an image with a lot of shadow and with well-defined areas of light and dark.

Step 2: Now you have your image you need to duplicate your image. To do this go to Image >Duplicate.

Step 3: Take your duplicated image, and remove color from it. To do this, select Image>Adjustments>Hue/Saturation and move the saturation down to -100.

Step 4: Posterizing breaks your image into three shades—black, gray, and white. To do this to your image, select Image> Adjustments>Posturize.

Step 5: To sharpen your image more, or define areas of your image, select Image> Adjustments>Brightness and Contrast, and increase or decrease the brightness and contrast of your image.

Step 6: Now you have your image clearly broken into three different stages. Print the three stages out. Check over your images to make sure you have defined the features enough.

TIP:

This is the technical way to produce your stencils and requires a lot of thought and concentration. You can make your image another way by tracing over an image and then cutting it out. For one-way stencils this is okay, but for two-way and three-way, Photoshop is recommended.

Stenciling—the basics

- A one-way stencil is very simple and easy to use.
- Wearing gloves is good so you can press down on your stencil with your fingers, keeping the detail flat against the wall and spraying over the cut out sections.
- It is important to be careful not to spray over the edges. You can gently move your fingers if you need to.

Two-way stencils

Most stencils are two-way stencils, one for the backdrop of the image or the outside shape, and one for the detail over the top. You can use more than two stencils to achieve more detail but it can get very tricky. When painted on the street, two-way is most commonly used.

- Working in black and white you can put white detail over black or black detail over white, so when making your stencil one will be your whole image cut out and one will be just the detail cut out.
- They must be the same size and the second stencil must be laid with accuracy over the first stencil or the image won't work.

For large stencils you can stick pieces of card together. Old record covers are good for this and fold away neatly. Keep this in mind if making a large stencil, as you need it to be portable to avoid damaging it for future use. You also want to keep your stencil so something that folds is very useful.

How to cut and make your two-way stencil

Step 1: To begin your stencil-making, you need to source your image. There are many websites that feature all kinds of stencils ready to print and use. Upload your image into Photoshop.

Step 2: You can make your stencil at US letter size (8 1/2 by 11 inches) but if you want to make it larger you can print it over two pages.

Step 3: Print out each part at full size and stick together, making sure your image is correct.

Step 4: Trim your image ready to be glued to some card.

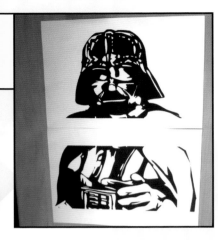

Step 5: Glue your trimmed and cut image to your card to reinforce it using a paper glue. Keep this flat until it is dry.

Step 6: Carefully cut out your stencil. Use a scalpel, available from all art shops. When cutting your stencil try to be as accurate as possible. The better you cut the better your image will look.

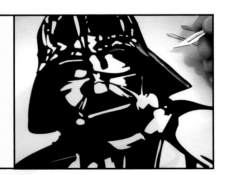

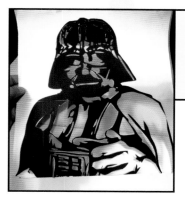

Step 7: You are left with a fully cut stencil, which you can also fold if you need to.

Step 8: For the background of your image you need to make the same stencil again, but only cut the background out. This section is for your detail to sit on.

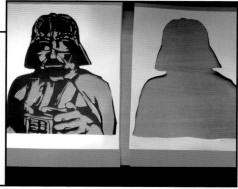

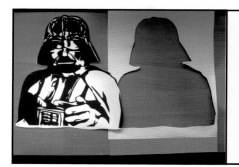

Step 9: Your two-way stencil is complete and ready to use. Keep your two sections together inside something flat like a book.

How to use your two-way stencil

Step 1: Place your background stencil against the wall or canvas. Keep stencil flat against the surface. Wear gloves, so you can spray over your hands to keep the stencil flat.

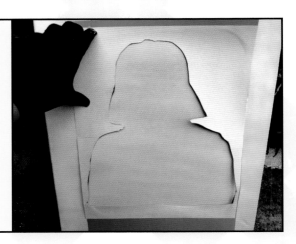

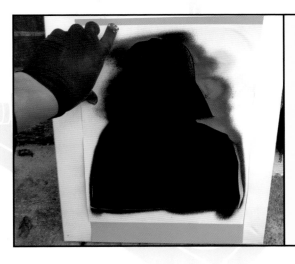

Step 2: Using gloves, apply spray paint to your stencil. You can move your hand around the stencil to keep it flat.

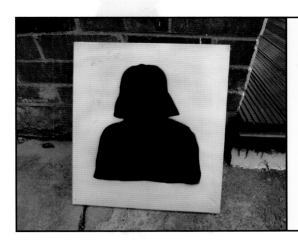

Step 3: Now you have your background stencil image ready for your second stencil.

Step 4: Place your second stencil, this adds detail to your image and must be placed as accurately as you can. Try moving your stencil around and looking for the correct position.

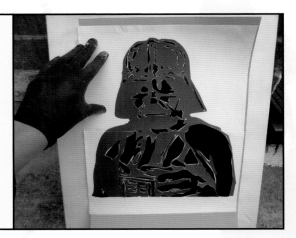

Step 5: Spray over the detailed stencil using your hand to keep all parts of stencil flat.

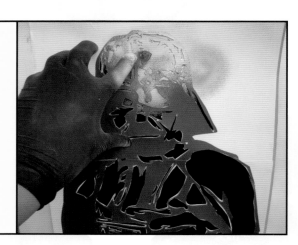

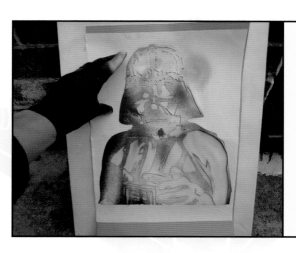

Step 6: Before you lift your second stencil, check you have covered every section as you don't want to have to reposition your stencil.

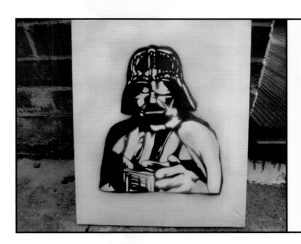

Step 7: Pull away your second stencil to reveal your finished image.

Step 8: For additional effects you can spray an extra backdrop. Try spraying some color where you're going to place your stencil. Freehand spraying is good as you're only spraying a simple background.

TIP:

You can make a one-way stencil to sign your work and keep as a stencil tag. This is a good way to be recognized.

How to cut and make your three-way stencil

Step 1: Each of your three images is used one at a time and adds the detail to your image (see step 6 of How to manipulate an image for stenciling, page 163).

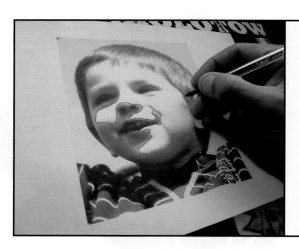

Step 2: Your image is broken down into three colors. To make this easier using a pen, mark out the light, dark, and middle areas.

Step 3: Each image will have different sections cut out so mark all three images.

Step 4: Now cut each section. You are left with three cut stencils.

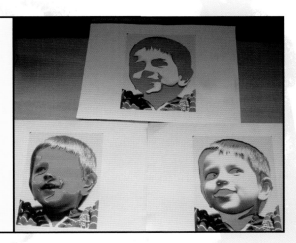

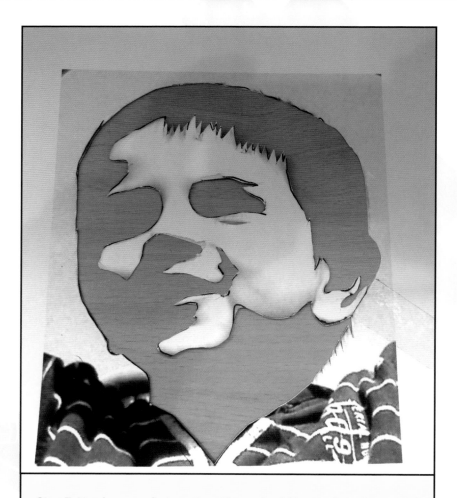

Step 5: Number your first section. Above should be numbered one as it is your base or background stencil.

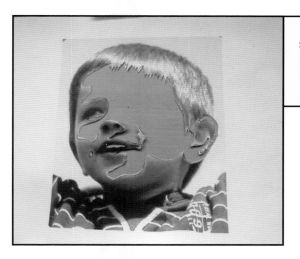

Step 6: Number your second section number two.

Step 7: Number this section number three. This is your third and final stencil that is the final detail. It's important to number and know which color will be used on each section.

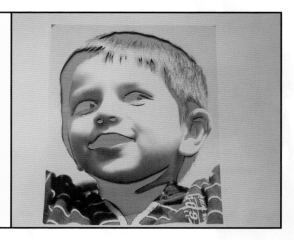

How to use your three way-stencil

Step 1: Place stencil number one.

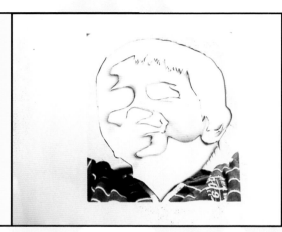

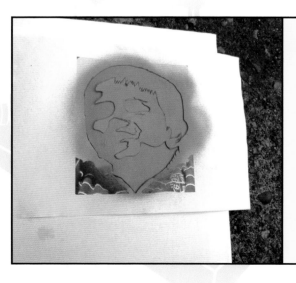

Step 2: Spray over your first stencil.

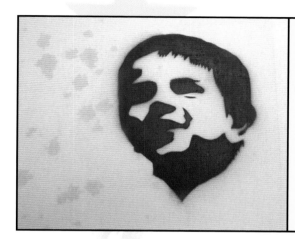

Step 3: Remove first stencil to reveal your base.

Step 4: Place your second stencil over the first. Be very accurate in your placing.

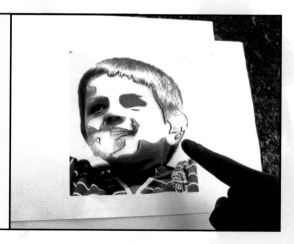

Step 5: This stencil, and most stencils, will have small pieces to spray, as I am painting onto white I am only spraying those pieces and not over the eye section. The base will show through enough on these parts.

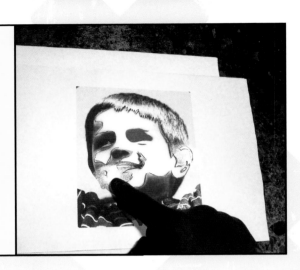

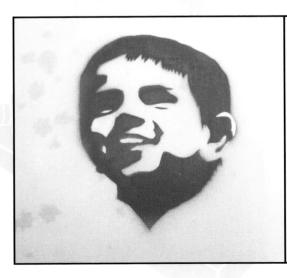

Step 6: Remove and reveal your second stencil.

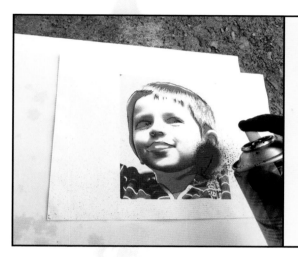

Step 7: Place your third and final stencil for your detail and spray.

Step 8: Remove and reveal your finished stencil image.

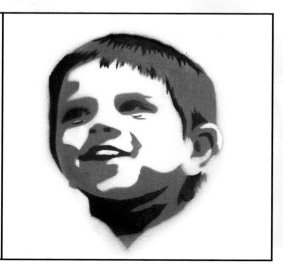

Step 9: Try repeating your image in a different shade. You can experiment with skin tones for different effects.

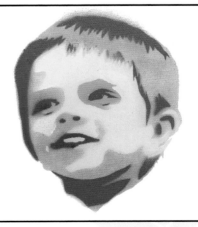

Step 10: Try using bright vibrant colors to create a pop-art style stencil.

Step 11: Once dry keep your stencils flat inside a book.

TIP:

Stencil art can create any image and on canvas can become a colorful work of art.

A cheat's art?

In traditional graffiti, stencils are not used as graffiti. It is a freehand art, and if you focus purely on stenciling you would not learn to use a spray can properly, and it would been seen by some as cheating. A graffiti artist would only use a stencil on a canvas as part of a mixed-media painting. Increasingly, the two art forms are merging together, with street artists and graffiti artists painting the same walls and streets, and even collaborating on projects. Art galleries represent graffiti and street art together as one art form because of the diversity of each art form, which is the right thing to do, as even though artists see a clear difference, there are strong similarities and both parties have the same goal—pushing graffiti further.

Chapter 8

Color

This chapter will explore the
techniques needed to get the best
out of your color selection, mixing,
and painting. Paint technology
has come a long way since the
beginning of graffiti, and here you
will discover skills to make the best
of the paints available to you.

COLOR

Graffiti today is of the highest color quality. Years of practice, with techniques being passed on from the earliest generations of the graffiti scene, combined with advances in paint technology, have encouraged this.

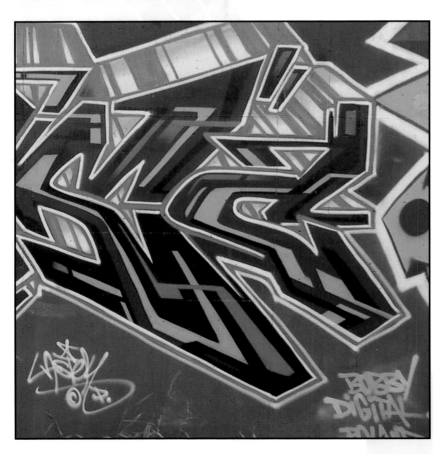

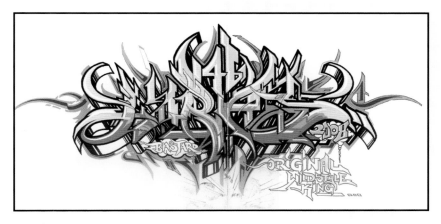

Above A paint pen sketch by Loras.
Despite five or six different colors being
used, cohesion is achieved with the tones
of color.

For over ten years now, spray paint has been manufactured for art only—
before then spray paint was manufactured to spray cars. When the new
graffiti paints were created, artists like Loomit and Tasso (both from Germany)
were invited by paint companies to come into their factories and to provide a
real insight into what the graffiti artist requires in a can of spray paint. This is
when the cap system really began, and every color you could imagine was
created. Colors were no longer light, middle, and dark—instead, on average
twelve shades of each color was made available. The graffiti artist could see
what colors were needed like skin colors and also created unique colors like
Loomit's Aubergine. This vast array of colors pushed all graffiti styles in a
major way, especially the 3D style and photo realism.

Left With graffiti you can afford to be
playful with color.

Color theory

To help your pieces work visually you should understand the basics about color—which colors work with each other, and which are likely to conflict. In the color wheel, each of these colors blend into each other naturally. You can use this as a guide for your color fades.

Look at the colors in the wheel—the colors that are opposite each other intensify each other. Opposite purple is yellow, and opposite red is green—these are perfect colors to make something stand out, or "pop," as these are complementary colors.

Left Color theory by graffiti artist Brave1.

Above In this color wheel, you can see that the opposite of green is red, blue is orange, purple is yellow, and so on. You can test this theory by choosing to invert a color image in Photoshop, which will show you the opposing color.

To give a warm look and feel to your piece you could use yellows, oranges, and reds. Just by using these colors you are suggesting fire, without any fire effects. You could complement this by using cold colors for your background such as blues, light blues, and white. A frosty look is achieved simply by using these together. I have outlined the examples in their complementary color.

Left Cool colors result in a frost effect.

Above Warmer colors work well with a contrasting blue background.

It is not only complementary colors that work well together. Using the same shades or the same hue can have a great effect. This is especially good for 3D effects like shadows and spheres, so your piece can jump off or pop out from a subtle background.

Using color for 3D

Look at the 3D cube. It is made up of three shades of red. To create 3D, the same shades are used in the sphere but fade to give a 3D effect. This use of color is what is needed to create 3D effects. I have used green, the complementary color of red as a background for the examples to sit on, showing the clear use of complementary colors and helping the 3D effect.

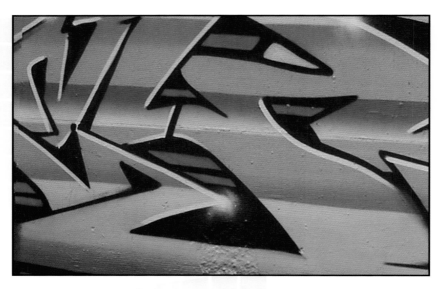

Above This piece works well because it works around the hues of blue and pink.

Color choices

Choosing colors that work together is an art in graffiti. The most diverse color scheme can work with amazing results, but can also go wrong. Spray paint naturally fades into the next color, but only really works if the colors are close to each other or of the same hue (like blue and purple, or red and pink). Some colors that do not fade together can still work together on the same piece.

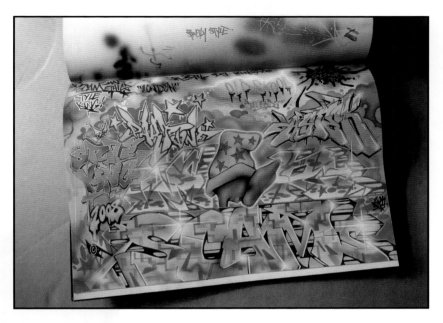

Above Experiment with color in your black book. "Scam" black book piece, Astek.

Value

Value is the lightness or darkness of a given color. Value is another way of referring to the shade of a color. If the main image features all dark values then you should consider softening (or lightening) the background color to avoid the image looking muddy.

When sketching in your black book you can experiment with colors. Standard pens like felt tips are okay but do not blend, and show lines when finished. By using quality pens like Letraset pantone pens, magic markers, or touch pens, you can achieve graffiti effects including fading and shadowing. The ink in these pens is very wet and designed to blend into each other. They also come in every shade. Like spray paint, they even come with a blender pen, which is not necessarily essential for your designs, but helps. This type of pen is used for many types of graphic art like comics and Manga art.

Above Have a sketchbook to hand to practice your fading with Letraset and magic marker pens. This helps you know how a fade will look but also means you can practice the level of pressure that should be applied to the pens.

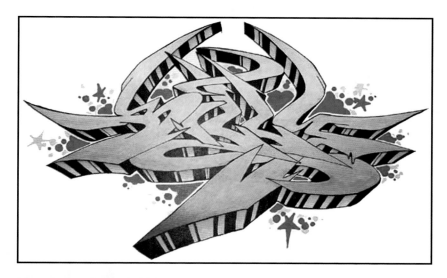

Above A piece sketched with Letraset
pens. The best brands of pens have a wide
range of colors on offer, of varying
nuances and tones.

Paint pens are another essential for your black book sketches. The paint pen
adds an actual paint effect to your sketches. You can add white highlights
over the top of your letters without fading, which is an essential effect for
most writers. You can also add light colors over dark—for instance a yellow
border straight over other colors. Paint pens work well on all surfaces, so are
good for mixed media on canvas. Paint pens like Posca and Edding are very
good, and come in many colors and sizes. Recently Molotow, the paint brand,
have released their own brand of paint pen, which matches their spray paint.
Vast colors are available, and are a must for your black book.

Graffiti colors

Classic colors in graffiti are warm colors like yellow, red, and orange, or there are cold colors like steel blue, light blue, and gray. Using these colors in one piece gives the effect of warmth or coolness without adding effects—the colors alone give that feel. In digital work (see pages 210–15), where you can be even more experimental with colors, try mint green, brown, or purple in the same piece, or a chrome effect where colors fade from the top and from the middle to create a mirrored landscape effect. A classic chrome effect can be achieved with blue for the sky at the top fading down, or brown for the desert fading down from the middle. Any colors that work together look great as a chrome effect and are very experimental.

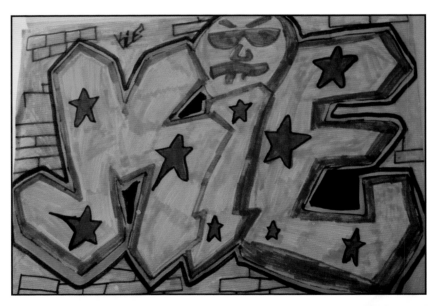

Above Graffiti artist Kie makes full use of color.

When deciding on a color scheme, try to be original with your color as well as your style. Black is an obvious choice of color to outline in, but you don't need to be limited to it. You could do your infill black and your outline white, and totally reverse your colors. White outlines look very effective and do not need highlighting as the outline is already glowing. When using pastel shades or yellows in particular, a black outline can sometimes be too much and change the colorful effect of your piece— reds and blues work much better. All the colors on your wall should complement each other.

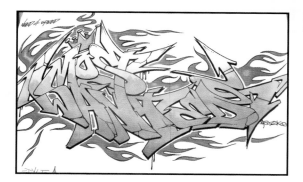

Left Color reflects form in this Letraset sketch.

Color, borders, and backgrounds

- Your background or cloud cannot be brighter or bolder than your infill color, as it is your piece you want to stand out and jump off of the background.
- Your outline color must stand out clearly against your infill. You could add a graphic or an effect in a similar color, and surround it with a lighter one.
- The border was originally used to bring out your piece from a chaotic background to avoid it becoming lost. Over the years this has become an essential aspect of a design.
- When choosing your border color, try to make it your brightest color. Never use a color already in your piece. A good choice of color will stand out from everything else at a glance.

How to make the most of color with paint pens

Step 1: Choose and test a selection of colors. The pens I use all work the same and blend into each other even though they're different brands. As long as they are good-quality markers they will work together well. These pens are expensive and quite difficult to come by and are acquired over time.

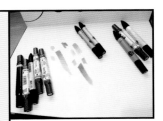

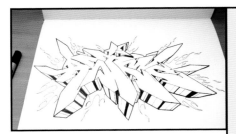

Step 2: I have already blacked out a sketch and erased any trace of pencil. I'm going to color the infill, the 3D, and the background flame. The flame works in the same way as a splat or a cloud, and will be colored the same way.

Step 3: Choose the shades to infill, and start at the bottom. When coloring, leave the top loose or open as I have done, as this allows the next shade to blend.

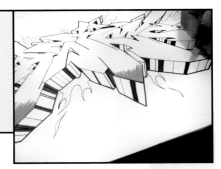

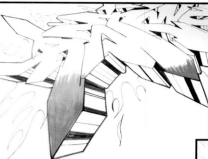

Step 4: Apply the lighter shade to the first, and again leave the top open. Go over the previous shade fully, this helps the blend to work. Apply this across the piece.

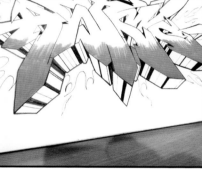

Step 5: Apply the third shade. Again go over the previous shades to help the blend work and leave the top of the color open.

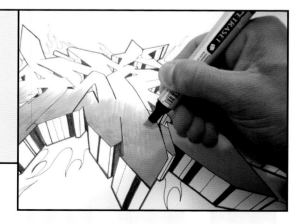

Step 6: You could draw a line in the final shade to show how far you're going to color. Concentrate on this area, blending very well.

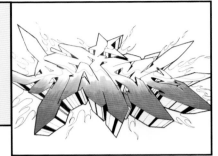

Step 7: Before moving on with the last shade (usually lightest), you can go over the blend to enhance the fade. Concentrate on where the colors meet.

TIP:

If you have a blending marker you could use it now, but it's not essential. I have not used one here.

Step 8: These pens blend into the white page, keeping white in the image is very effective and something that takes a lot of thought. I have added some yellow to the top, leaving a large white area. White will also be left in the 3D and in the flame.

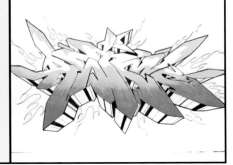

Step 9: Now you can move on to the 3D block. Start at the bottom with the darker shade and leave the top open for the next shade. This is a small area to achieve a fade, so only add a little to start. Apply this evenly at the bottom of all 3D blocks.

Step 10: Apply the second shade. Remember to leave some white.

Step 11: Apply this to all previously shaded 3D areas, and go over the previous shade to help the blend.

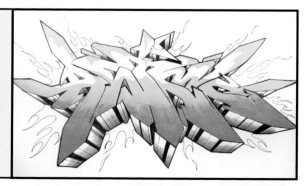

Step 12: This section is small so I am going to use a blending marker to help the fade work. With the blender, color in the entire section and concentrate on where the colors meet. Try not to let the blender go onto the black outline, as you will blend into the black as well.

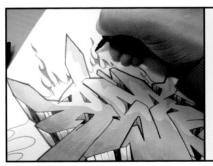

Step 13: I have chosen a flame background. Clouds and splat backgrounds would be colored in the same way. Again, start with the darkest shade and color the edges.

Step 14: Apply the second shade and remember to go over previous shade.

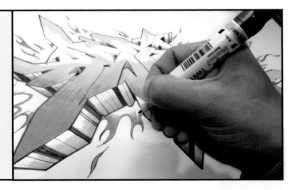

Step 15: Apply the third and last shade, coloring over the previous shades and leaving white closest to the letters.

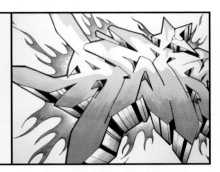

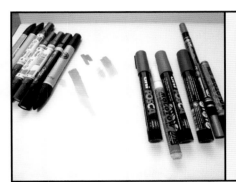

Step 16: I have chosen a small selection of paint pens for the finishing touches. These are for adding any effects to the piece, as they are paint and will go over any thing you want.

Step 17: Using a white pen, apply the highlights in exactly the same way as you would on a piece in spray paint (see Highlights, pages 57–9). By adding white highlights, the effect enhances the white areas you have left.

Step 18: Straight through the middle of the piece, apply some paint effects like stars and dots in different sizes.

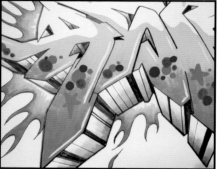

Step 19: When dry, in another paint pen loosely overlap the dots. This gives depth to the infill. You can add as many as you like. Keep the dots and stars together.

TIP:

This will work the same way for clouds and splats.

Step 20: Finishing touches can be applied to add effects and a more complex feel to the whole design. Using a middle gray marker (not a paint pen) adds a shadow to the flame.

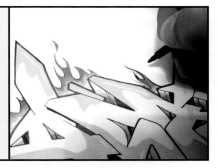

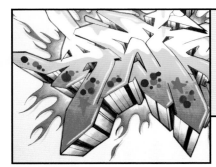

Step 21: Add this shadow effect to one side of the flame or cloud.

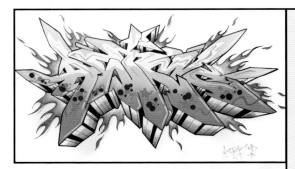

Step 22: Just to add some more detail I am using a silver paint pen. Where you stop now is up to you—the more detail you add, the more complex the infill will be.

Chapter 9

Taking Graffiti Further

Graffiti is constantly evolving as an art form, and it is no longer reserved for the street. Artists are moving toward graphic design prints, t-shirt designs, and stickers as a way of increasing their audience and creating viable businesses.

TAKING GRAFFITI FURTHER

To take graffiti further, Photoshop is the best place to start. Everything you learn will be useful in many ways. You are working on a universally recognized program used by the design industry which can open your mind to the world of media print and design.

Above A concept for a designed sticker.

Artists first used Photoshop to edit their photos and connect them to create panoramic images. You can learn a lot by experimenting with Photoshop and becoming familiar with the different effects available. Eventually you will be able to add or remove something from your images. Many artists will edit images of their work, usually cleaning up the background of their artwork or even correcting a mistake. Artists can also test out concepts or color schemes before taking to wall or canvas.

Photoshop and industry

The tools you use in Photoshop can create unique, colorful artwork with fantastic results. Artists can learn about and develop light, shadow, and depth. These images can be used for print and design for solo projects, but also for commissions for industries like fashion and the art world.

Printing

A little Photoshop knowledge is recommended for any kind of printing. All types of design and print, like for instance a screen print, involve Photoshop or another similar program during a stage of production. During your graffiti

career you will be inevitably asked to produce something like a t-shirt design or a graphic version of your work.

Editing images for prints

Images can be scanned into Photoshop and then edited as a piece of art. When you want to reproduce a perfect black and white image of a wall, it's best to use a scanner so you can edit it easily. After editing, this image can be printed onto anything you want, whether a personal project like producing graffiti stickers, a transfer for a t-shirt, or a more professional project such as submitting your design to a printing company to be silk screened onto a t-shirt. Being proficient with Photoshop to produce art is not only useful in graffiti and your work but also in career prospects. Photoshop is an amazing program as it is both an introduction to the world of editing imagery and the gateway to other programs used in the graphic design field.

Above A clean, digital graffiti design, ready for print.

How to create graffiti art digitally for print

Photoshop is a vast program that I can only touch upon in this book. It has many rules and connections with other programs and it takes a lot of skill to use. An image created for a commission should be created using layers until the image is complete, so things can be changed at the last minute if required.

On the following pages is a simple introduction to graffiti art and Photoshop. There are many ways to create the image I have created, and there are many effects I have not used, but by experimenting with Photoshop you will discover this.

If you have some Photoshop skills you will excel in this or if you are learning Photoshop in college you will see how much there is to learn. Every graffiti artist needs to have some knowledge of using Photoshop even if it is just to edit photos.

Step 1: Using a scanner, scan in an outline. If you intend for the artwork to be printed, it is best to scan at 300dpi. You need to have already blacked out and erased any trace of pencil. The better the artwork you scan in the better the results will be, so try including 3D.

Step 2: Now the image is on screen, choose Image from the drop-down menu and go to Adjustments >Brightness/Contrast. Increase the Contrast to make the image brighter. You may not need to use this depending on the quality of the image, but if the image is of low quality it can help.

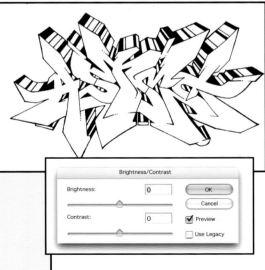

Step 3: Using the Magic Wand Tool from the Tool Bar you can select the image outline by clicking on elements and holding down the shift key. You must accurately click onto the outline so only the outline is selected.

Step 4: The outline needs to be changed to a computer image so it prints well. While the image is selected choose Edit from the drop-down menu and go to Stroke. Stroke can help you achieve similar effects to the outline, border, and highlights you get when working with spray paint (see page 46–56). For the outline, choose Center in the Stroke options and choose a color, I am using black. The size is experimental, but for an outline like this choose 2.

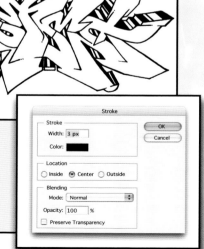

Stroke

Stroke
Width: 3 px
Color:

OK
Cancel

Location
○ Inside ● Center ○ Outside

Blending
Mode: Normal
Opacity: 100 %
☐ Preserve Transparency

Step 5: Using the Paint Bucket Tool from the Tool Bar, drop some color into the letters of the image so you have a flat color infill.

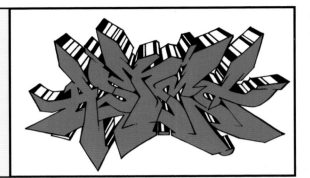

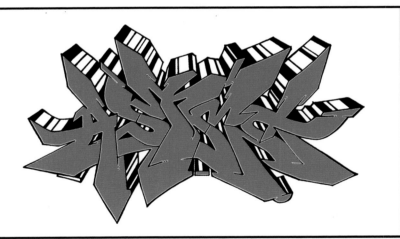

Step 6: At this stage, concentrate on highlights. This contrasts to the time that an artist would usually add highlights using traditional methods. Using the Magic Wand Tool from the Tool Bar, select the inside of the letters. When all insides are selected choose Edit from the drop-down menu and go to Stroke. Select Inside and change the color to White. Choose the same size as the outline (2). You could try using 1 for a smaller width of highlights.

Step 7: Using the Magic Wand Tool from the Tool Bar, select the inside of the letters and once again notice the Wand selects inside the highlight. You could use a Hard or Soft Brush Tool here. This effect was achieved with a Soft Brush Tool. To achieve this approach, choose a Large Soft Brush. You can afford to be experimental with this stage of the graffiti design. Using the Soft Brush paint in some color from the top and the bottom. Like on any other piece I'm using complementary colors, which fade well.

Step 8: Using the Paint Bucket Tool from the Tool Bar drop some color into the 3D block. I am just going to keep this one color but you can experiment here with more fades if you select the area first.

Step 9: To create a background, first copy the entire image by using the Marquee Tool from the Tool Bar to select the whole image. Choose Edit from the drop-down menu and go to Copy>File New. The new document that pops up will be the correct size as the image has been copied. Choose a color for the background and fill using the Paint Tool. Go to Edit>Paste to paste the original image over the new background. Using the Magic Wand Tool select the unwanted background and delete it using delete on the keyboard. You now have the image in two Layers which allows you have greater freedom with the image and to work on new effects. The effects described from Steps 10–16 can only be used if the image is in two layers i.e. copied and pasted.

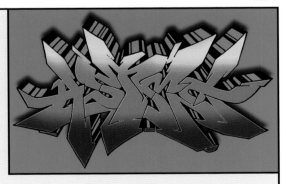

Step 10: Go to Layer>Layer Style in the Layer Palette and select Drop Shadow. You can use black for most images. I'm using dark green to match the background better. I am also putting the shadow above my image to follow my 3D block. Viewing the work from different distances, experiment with the shadow effects.

Step 11: Border the image. Go to Layer>Layer Style in the Layer Palette and select Stroke. Choose the color and size. Experiment with colors and sizes to see what works. When you have decided on a color

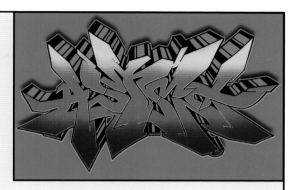

go to Layer>Flatten Image in the Layer Palette. This flattens the image into one layer.

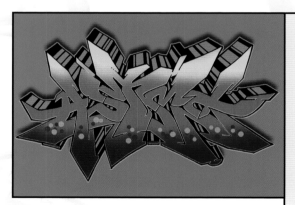

Step 12: To add more effects, select the Brush Tool from the Tool Bar. This time choose a Hard Brush and make it small enough to create effects inside the letters. Simple dots in different sizes are a good start.

Step 13: To create sharp effects select the Polygonal Lasso Tool from the Tool Bar and carefully create some shapes. Color them as you go using the Brush Tool.

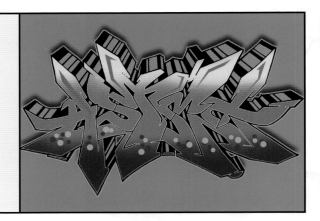

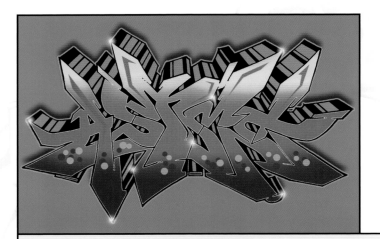

Step 14: Using the Brush Tool from the Tool Bar add shine. Change the Brush to a Small with a Soft edge. In white paint small shines where you want them. To create a sharp shine use the Polygonal Lasso Tool from the Tool Bar and creating it freehand, add a glow to the center.

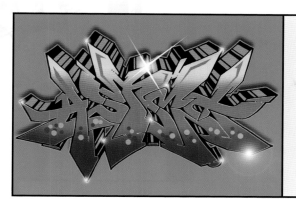

Step 15: A great finishing effect is the lens flare. It gives an atmospheric feel to any image. Choose Filter from the drop-down menu and go to Render>Lens Flare, and have an experiment.

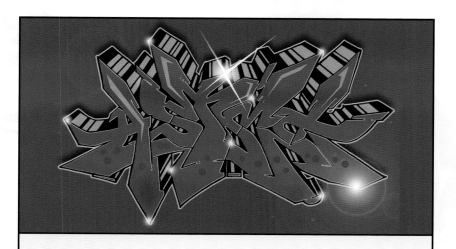

Step 16: Go to Image Adjustments>Hue/Saturation, and change the hue to alter the colors of the image. You could try adjusting the whole image or selecting sections. This effect is a lot of fun and is great for choosing and creating color schemes. Artists regularly use this after scanning in a piece of work, as it can add an interesting quality to the piece.

What's next?

To use this piece for personal projects all you need is a standard printer connected to your computer. A great introduction is t-shirt transfer paper and sticker paper that can be bought from most computer stores. Follow the instructions carefully on the packaging to put the paper in your printer. When using transfer paper, print your image onto the transfer and heat set with a heat press or iron onto your garment. Instructions for this will be on the transfer pack. The

Above and right A finalized graffiti design on a t-shirt and sweater.

transfer is also great for a test image or a one-off which you may want to have silk screened at a later date. You can use any colors and put the transfer anywhere on your t-shirt or garment. To use this image for a silk screened design, you would submit your image to a print company and they would do the rest. They will break your image down into sections of color and fading and use a different screen for each color. The print company would then give you a quote on how much your design would cost, each color adds to the cost. Most printing companies will offer discounts for bulk orders.

Above When sending a design to the printer, be sure to leave clear measurements and guidelines on the document.

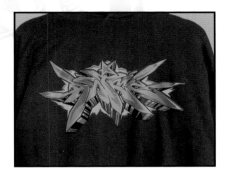

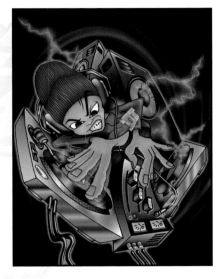

TIP:

You could submit the image to be transferred by a print company for better results.

Using sticker paper is very easy. By duplicating your image many times onto the same page, when printed you can then cut out each sticker. Many artists do this and the stickers have a professional finish.

Transfer vs. silk screen

Transfers are widely used in industry but can be done at home, allowing you to use as many colors as desired as it is one image and one print. Silk screens are different as each color costs. The quality of transfers is very good but some care is needed to maintain your printed garment like washing inside out on a low heat.

Silk screening is not only a superior way to print, but it is also a piece of art in itself, as your image is being recreated in paint onto your garment the same way artists like Andy Warhol silk screened his famous images on to canvas and many other mediums.

Silk screen printing is very durable, tough, and stays bright and bold for years. The fact that each color adds more cost is a challenge for artists as intense images are harder to create in one color.

Graffiti glossary

all city: To go "all city" is to get your name up across the entire city area, so that everyone knows who you are and has seen your tag.

black book: A hardcover sketchpad where you should document all your graffiti designs. Within it you can produce graffiti effects using a combination of pencil, pen, and paint pens before you take to the wall or canvas.

(street) bombing: To tag walls or the street is called "bombing" or "street bombing." Much of this is illegal.

border: You can border or second-outline your letters to bring them off the wall. Your border can be one single line, or a thickly exaggerated line. You can use borders to create many different effects, such as glowing and dripping.

burner: A burner is a successful wild style piece, with bright colors and good style, seeming to "burn" off of the wall.

color shadow: A method of coloring images using darker hues as an extra layer on top of your coloring.

complementary colors: Opposite colors that intensify each other when used together.

composition: The placement or arrangement of visual elements or ingredients in a work of art, as distinct from the subject of a work.

drop shadow: A drop shadow effect separates graffiti letters from their background, using drawn-on shadows to give the impression that the letters are raised above the shadows behind them. This helps to make the graffiti letters stand out.

dub, or dub-style: The dub is a progression of the throw up, neater and more precisely painted. It is a two-color piece and gives the throw up its identity and separation from other styles. A blockbuster is a huge dub.

fading: The same technique as blending, fading is used for a lot of effects and can be done in many ways.

foreshortening: A term used in perspective drawing to suggest that something appears closer to the viewer than it actually is, because of the angle at which it has been drawn.

half-tone: This is the transitional area from the shade into the light. The more gradual the turn of the form, the more half-tone there is. An object with a sharp edge in light and shade—like a box—will have little or no half-tone.

highlight: The brightest part in the light.

hue: The value of a color of a given object.

infill: The solid fill, or interior, color of letters on a piece or throw up.

intensity: This refers to the amount of a single color in the makeup of another color.

mixed media: You can use different types of paint to achieve your goal. For example, lots of graffiti artists use spray-paint backgrounds with paint pens on top.

mugsies: Graffiti characters.

overspray: In graffiti this is when paint is accidentally applied to an unintended area. This can occur when applying shadows to letters and you may need to touch up parts of your outline affected by overspray.

perspective: Systems of representation in drawing and painting that create an impression of depth, solidarity, and spatial recession on a flat surface.

photo realism: The attempt to create or reproduce a photographic image with graffiti.

proportions: In art, the size, location, or amount of one part or thing compared to another.

realism: This is a graffiti style that represents things as they really are, without idealization.

tag: A tag, or alias, is your stamp or your mark for other graffiti artists to know you by.

temperature: Colors can be warm and cool. Using temperature theory helps you to set the mood.

throw up: A quick and simple piece either done in one color or two. Throw ups can be painted in any color, and are used for impact and repetitive placing.

tone: The enhancing effect of adding gray to black and white artwork. Used to emphasize form, mood, and shadow.

wild style: A complicated construction of interlocking letters. A hard style that consists of lots of arrows and connections. Wild style is considered one of the hardest styles to master and pieces done in wild style are often completely undecipherable to non-writers.

Photoshop glossary

adjustment layers: These work in the same way as transparencies, so you can apply an adjustment (such as hue/saturation changes) on a layer and it will become an adjustment layer. You can create a stack of layers. When you look through the adjustment layer everything seen through it seems to have that adjustment. However, it doesn't actually change the layers below and therefore gives you a lot of control over what you do.

gradient tool: A gradient is a fill consisting of two or more colors blending together. The gradient tool allows you to create a gradient and use different gradient styles, such as linear and angular, in your piece.

lasso tool: The lasso tools are provided in three variations. The lasso tool and Polygonal Lasso tool which allow you to draw both freehand and straight edge sections, whilst the Magnetic Lasso is ideal for edges set against high contrast backgrounds.

magic wand tool: The Magic Wand tool allows you to select an area of an image based on its color. The tool is located near the top of the Photoshop Toolbox. When you click an area in an image with the magic wand, all areas that are a similar color are selected. You can specify various options to determine the exact selection.

marquee tool: The Marquee tool is the most basic of selection tools and often the one most useful. This tool is used to draw selections based on geometric shapes. Specifically, the marquee tool allows you to draw rectangular and elliptical selections.

paint bucket tool: This tool can be used to fill or 'paint' a selected area.

Index

Credits

All other images are the copyright of Quintet Publishing Ltd. While every effort has been made to credit contributors, Quintet Publishing would like to apologize if there have been any omissions or errors—and would be pleased to make the appropriate corrections for future editions of the book.

T = top, L = left, C = center,
B = bottom, R = right, F = far

Astek
astekz@hotmail.com
www.astekz.com
10; 11B; 14; 23; 24; 25L-T; L-C; L-B; 30; 32; 36; 37; 66; 67; 72; 73T; 74; 75; 76; 77; 78; 80; 84; 86; 90; 91T; 94T; 97T; 102; 103; 108; 110B; 117; 122; 123T; 129; 136; 143L; 153T; 156; 157; 158; 184; 188; 190; 191; 192.

Astek and Skez
46–63.

Bonzai www.graffitinwx.com/bonzai
105T; 123B.

Does www.digitaldoes.com
94B; 97B.

Keen www.keen1rock.com
91; 96.

Ler
144B; 152.

Loomit www.loomit.de
109B; 116; 118.

Loras www.flickr.com/loras1
11T; 105B.

Steam156
www.aerosolplanet.com
12B; 13; 73B; 81; 110T; 143R; 159.

Trans1
145 C-R, B; 153B.

Other
8 © T-KID; 9 © Letty Lyons; 12T © Choci; 15 © Vaper; 19 © Shutterstock; 25T-R, B-R © Molotow; 79 © Darren Moore; 16 © Seak www.seakone.com; 87 © Cope2 www.cope2.net; 109T © Lovepusher; 119 © Delta www.deltainc.nl; 142 © Shok 1 www.shok1.com; 145C-L © Belin www.belin.es; 160 © Banksy www.banksy.co.uk; 186 © Brave1 www.braveone.co.uk.

With thanks to:
www.artcrimes.org
www.bleklerat.fr.free
www.daim.org
www.kweenzdestroy.com
www.markbode.com
www.mode2.org
www.picturesonwalls.com